Art Workshop
with Paul Taggart

Your Painting Companion

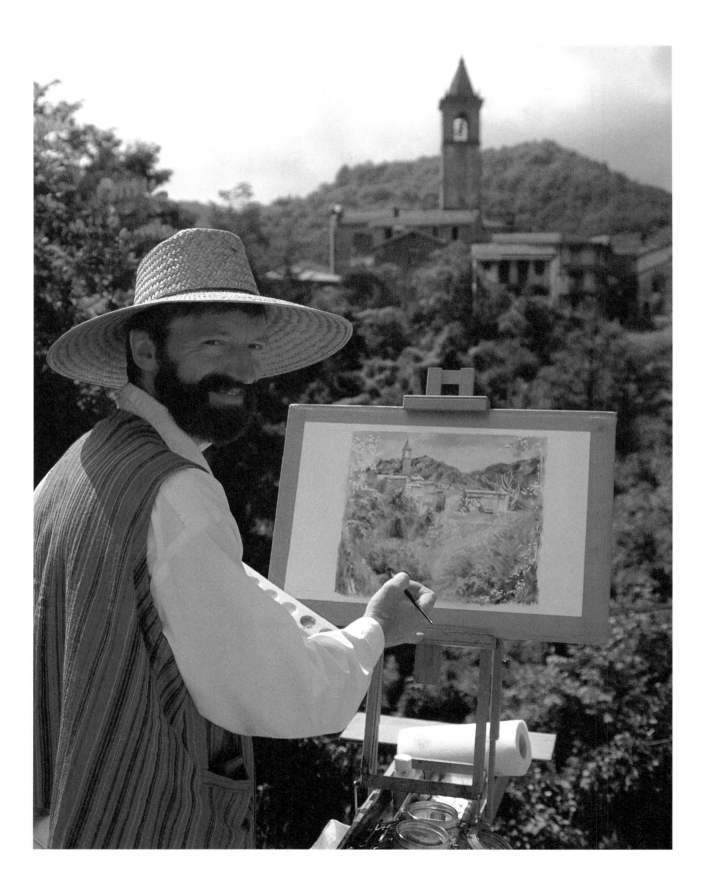

Art Workshop with Paul Taggart

Your Painting Companion

EBURY PRESS
London

To May and Bill
My Mother and Father
For All Their Love

First published in 1993 by Ebury Press
an imprint of Random House UK Ltd,
Random House, 20 Vauxhall Bridge Road,
London SW1V 2SA

Editor: Cindy Richards
Designer: Behram Kapadia

Set in Melior by DP Photosetting, Aylesbury, Bucks
Printed and bound in Great Britain by Butler & Tanner Ltd, Frome, Somerset

ISBN 0 09 177420 9

Contents

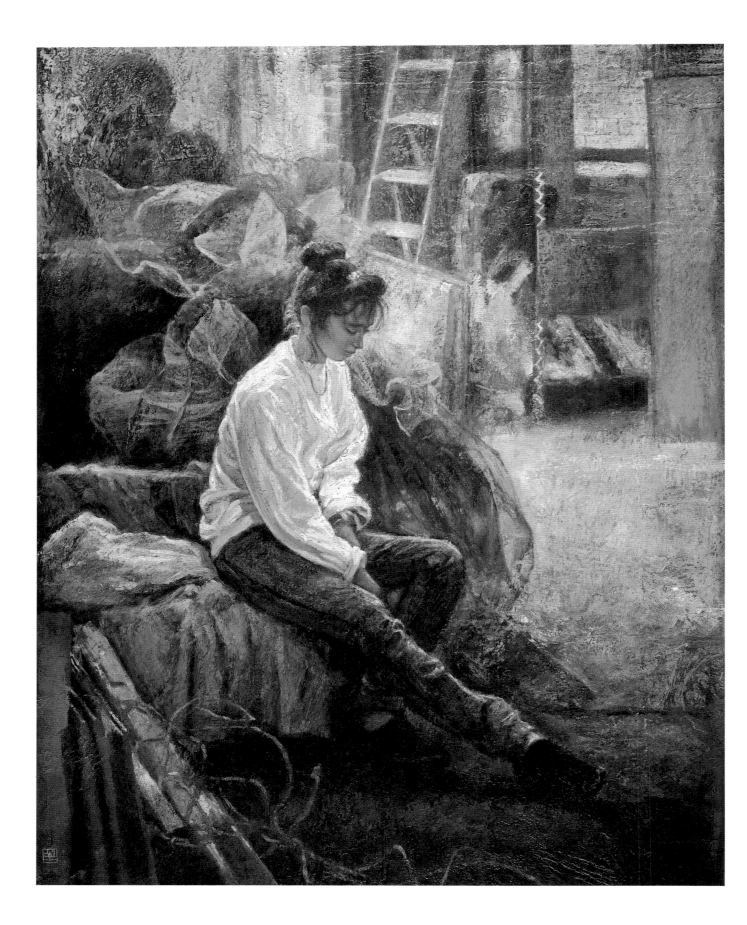

Let's Paint

When I am painting out of doors I'm approached by people of all ages, many of whom tell me how they too would love to paint. I quite naturally ask why they don't and more often than not I find it's because they weren't given the right sort of encouragement, became frustrated at their first attempts and soon gave up. I can understand this reaction: to make mistakes in public whether it's at school, college art class or adult education centre, can be a humiliating experience. It's a great shame though that so many people miss out on the chance to develop their creative potential and the newly-acquired watercolour, oil-painting or pastel set makes its way to the loft to gather dust.

My aim in this book is to make sure this doesn't happen. I will be your painting companion, always there to solve any problems and offer encouragement when things seem to be going disastrously wrong. Indeed, in my experience, it is often from the apparent disaster that the best results are obtained and the most important lessons learnt.

Before I go any further, however, I would just like to dispel a couple of myths which stop people trying to paint. Firstly, the belief that it is the sole province of naturally talented individuals. In my opinion, anyone can learn to paint. Obviously some take to it more readily than others, which is exactly what you'd expect when any group of people take up a sport or activity.

Secondly, the expectation of instant results. If you took up golf tomorrow you wouldn't expect to enter a championship by the end of the week. You would need to spend time learning the correct grip, stance and swing before you even attempted to hit the ball. Learning to paint is no different; you have to acquire certain basic techniques and practise with them before embarking on a major piece of work. So, don't expect a painting on your first day, but do keep the work so that you can look back and see your progress. You will be pleasantly surprised.

Now let's get down to the practicalities of how you start to paint. In the following pages I have started with a brief introduction to the most popular media available to the painter: watercolours, oils, pastels and acrylics. I look at what they are made of, their differences and similarities. This is followed by a few tips on buying materials, a word or two about painting styles, how to make time for painting, where to paint, photography and finally some general advice.

We are then in the main body of the book where we open with a section on sketching for painting. This is a good place to start as all the advice given is applicable to whatever medium you decide to use. I have deliberately called it sketching for painting, not drawing, as drawing immediately makes people think it's technical. Believe me, it isn't. Pick up a pencil, start to scribble and you are already well on your way.

There is then a section on watercolours, pastels, oils and acrylics but they are not presented in any order of priority. Each section contains a list of materials, a series of artstrips, a step-by-step guide to painting out of doors and at home, plus a series of common problems and some tricks of the trade.

The artstrips were devised by me as a friendly and totally visual way of guiding you through the various painting processes. Don't feel you have to master every technique shown in a section before experimenting with a particular medium – they are there to show you what can be achieved not what *must* be. A series of paintings, featured at the end of each set of artstrips, show you what can ultimately be done using the techniques and processes described up to that point.

The last section looks at colour mixing and I give my no-nonsense approach to the colour wheel and how simple it is to use.

I would suggest you read through the entire book and then select the medium you would like to tackle first. Re-read the section and then begin. Happy painting.

Painting media

Paint is created by mixing pigment (the raw colour) with a medium (the adhesive). Think of pigment as a coloured powder which on it's own cannot stick to a surface. To achieve this a medium or adhesive is required. There are several different types which in turn create the different painting media.

In *watercolour* the medium is a transparent gum which dissolves in water. When the water evaporates off, the gum dries, pinning the pigment to the surface. If the paint is rewet, the gum re-dissolves and the paint becomes fluid again.

Pastel is referred to as a 'dry medium' as there is no fluid in which the pigment is dissolved. Gum is once again employed as the medium but it is used purely as a 'binding agent' to hold the particles of pigment together in stick form. Consequently, the smaller the quantity of binder, the more vulnerable the pastel is once it is applied to the painting surface.

With *oil* paint, however, the medium is a transparent oil. This dries by a chemical reaction with the air and hardens

Introduction

to produce a film which fixes the pigment in place. The oil, once dry, is difficult to re-dissolve making this painting medium more permanent than watercolour.

Acrylic paint depends on a medium which hardens to a transparent plastic film once all the water has evaporated off. This plastic, or resin, is fluid and white while wet and is referred to as an emulsion. Acrylic is therefore soluble in water, but once dry can only be removed by the application of powerful alcohols.

You can see from this that all paints and pastels are produced from a common family of pigments. The choice you are faced with is which one do you feel would most suit and excite you.

I am often asked which of the media I prefer. I always answer that I have no preferences as each medium possesses its own unique characteristics that I employ according to the subject I am painting and the effect I wish to achieve. You don't need to concern yourself, however, about when to use a particular medium as this will become instinctive as you gain experience. Eventually, you will also discover when and how to use them together as 'mixed media'.

I would strongly recommend that you try all the media at some stage, but because of their differences, don't try them all at once or you will become confused. Neither should you become so proficient in one medium that you are unwilling to experiment with the others. Just think of the freedom you'll have if you manage to master all the media. For example, you'll be able to exploit the fluidity, transparency and speed of watercolour; the depth, richness and texture of oils; the versatility of acrylics and the intense colour of pastels.

Materials

Each section of the book gives you sound advice on the materials you will require and I have attempted to keep these within the reach of most pockets. By limiting the range of materials to begin with you will not only learn to

be more versatile with what you have, but you will also cut down on waste, thereby saving money. It's also easier to carry when painting outside. Acquire extra equipment only when you are absolutely convinced you cannot continue without it.

Although I recommend buying few materials, I do urge you to buy the best quality that you can afford. The best results come from the best materials and I have known many students suffer feelings of inadequacy which are the result of poor-quality materials, not their lack of skill. Don't always blame yourself and do try out different materials. After all, we don't all feel comfortable driving the same make of car so why should we feel comfortable with the same make of brush or watercolour paper.

Remember too, nothing of worth is achieved without effort. If your first attempts are disappointing don't worry, we have all gone through the same learning process to master our craft. Even the great masters had their mentors. In their work we see the product of a lifetime of accumulated skill which should provide you with inspiration, never feelings of inadequacy.

Style

Beginners often wonder whether they should cultivate a particular style. Look at the work of others. The artist can take the simplest of subjects and, by the exciting manipulation of the paint, endow it with a uniquely personal quality. Style is not something which should be consciously sought, it should be a natural development of your expertise in handling the materials. The best advice I can give is to paint, paint and paint, preferably from nature. Time and experience will mould your style.

Time

The next difficulty many of us experience is how to find the time to paint. I'm afraid that there is no easy answer to this one except that you have to make the time. Do try to set aside a regular spot each week in which to paint. Many people find that joining a class or an art club provides the necessary impetus to paint regularly. Or you may find that a friend is willing and happy to paint with you and you can arrange to meet regularly in each other's homes. The support of a fellow painter will also give you the courage to venture outdoors to paint as you can boost each other's morale. Your fellow painter will also provide you with a measure against which to judge your development.

Place

I would urge you, if at all possible, to turn a corner of your home into a work area. There is no need for a full studio, just somewhere to retreat where you can work in peace and without interruptions. A good work surface on which you can spread out and leave your materials is invaluable. You'll find that there is nothing more frustrating than having to get your materials out afresh each time, only to

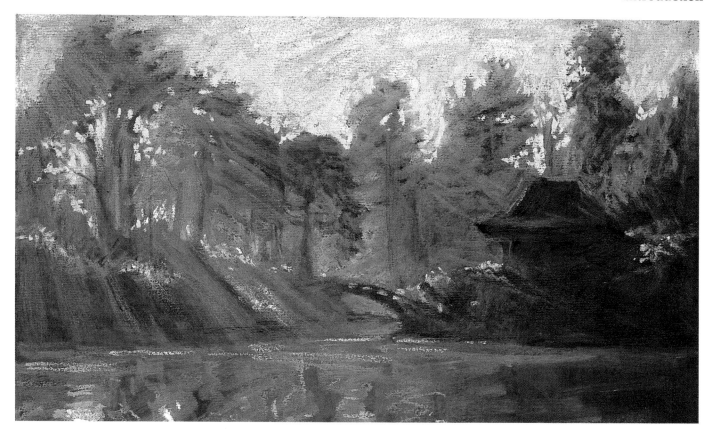

have to clear them all away again in a matter of hours.

Good lighting is also a must. I find the worst times of the day are early morning and twilight when the quality of light is constantly changing. The ideal situation is a room with a north-facing window as this ensures a fairly even light source. We do not, however, all live in homes with the ideal conditions. My advice would be to ensure that the artificial light sources are equal to the natural light at the height of the day, even if this means installing extra lights. Working in ever-changing light conditions is not only tiring but very trying.

The absolute ideal, of course, is to work out of doors and when the weather permits, I recommend you do so. At first it will undoubtedly be a little nerve wracking, especially when passers-by stop to look over your shoulder. However, you will learn much more about light and colour mixing by observing the changing colours of nature than you ever will staying indoors. So persevere and soon you will become accustomed to curious onlookers. In fact you will meet some very interesting people and may even find a new friend.

Reference

There will be occasions when it is impossible to work directly from your subject and this is when photographs can provide an invaluable source of reference.

Your subject may, for example, be constantly on the move, or the light changing rapidly, or it may be too dark, or the weather too bad for you to remain outdoors. Remember to take your camera with you at all times. Quite often you may be in the middle of a painting when something else about the subject strikes you. Capture it, rather than miss the opportunity. You may well be in the middle of a painting when the weather quite suddenly changes. Photograph your subject and finish your painting at home.

Your one day spent painting out of doors, may well yield several subjects for future paintings. So always carry around a small drawing book in which to jot down a few thumbnail sketches (see page 10). You can then work from these at home.

General tips

It is essential when working out of doors to have a good strong easel which can withstand the wind on a blustery day and is light enough to carry with the rest of your equipment.

Another point to remember is to dress well when painting outside. Remember once you are set up, you may well be standing there for hours. I always take an extra jumper with me, plus a scarf and, for sunny days, a wide-brimmed hat, a sunscreen and some insect repellant, plus a carrier bag for my rubbish.

Sketching For Painting

How do you start a painting? How do you decide on the composition?

If you simply start in the middle, by the time you reach the edges you will have run out of space.

It is much better to set down your ideas first as a series of thumbnail sketches. This will save a lot of rubbing out later. Use a 2mm clutch pencil with 2B leads.

If you think of your thumbnails as scribbles, your approach will be looser and more imaginative. If they become easily recognizable they have become too detailed.

Your thumbnails should be spaced apart and well away from the edge of the paper to avoid confusion or an imbalanced composition.

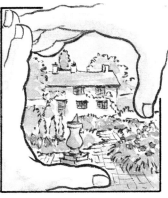

I find it useful to frame the view with my fingers so I can visualize the best proportions for the outer edges . . .

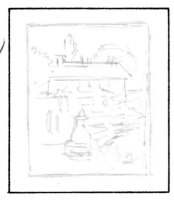

. . . and your first thumbnail can reflect this.

When working from a photograph, its proportions often dominate the first thumbnail even though they may be inappropriate.

But remember that you can change the position and proportions of the compositional elements within this format.

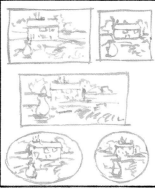

You can also change the shape of the outer edges surrounding the composition.

It should take you no more than 10 minutes to produce six scribbles. Any longer and you are overworking them, turning them into drawings.

The thumbnail you choose is the most important decision you will make regarding the overall composition of your picture.

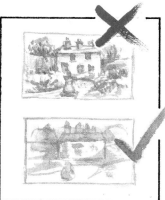

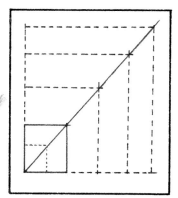

Using this method, many artists, all painting from the same spot, will come up with their own unique composition.

If you cannot decide between two thumbnails, block in some shading with the side of your pencil or use a graphite stick.

Don't make too good a job. Remember this is a scribble not a finished drawing. Your thumbnail controls proportions, detail will be extracted directly from the subject.

A diagonal line through the thumbnail can enlarge or reduce its size while retaining its proportions.

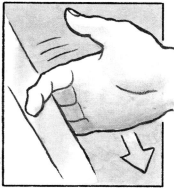

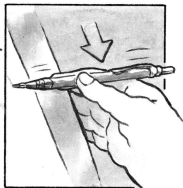

However, if you are working to the fixed proportions of a canvas your thumbnails must echo these. Use the diagonal of the canvas to establish reduced proportions of thumbnails.

With watercolour, having decided on the format i.e. portrait or landscape, turn your stretched paper the same way. This employs the greatest surface area of your paper.

Run three fingers down the edge of your drawing board.

Balance pencil between spare finger and thumb and draw a faint line parallel to the edge of the board and 12mm (½in) in from the gumstrip.

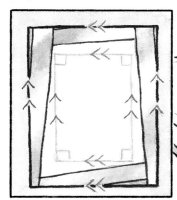

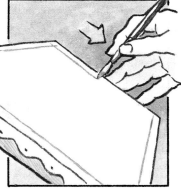

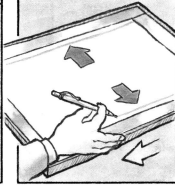

In this way, even if the gumstrip is crooked, your lines will be straight ensuring the resultant rectangle has right-angled corners.

With oil painting, use a similar method employing your brush to create an 8mm (⅓in) margin around the canvas. This approximates the amount of canvas that will be lost under the frame.

Here if we were to transfer the thumbnail proportions to our watercolour painting, there would be plenty of space at the sides, but it is tight at the top and bottom.

Draw the tight edges in first (about 12mm (½in) from the gumstrip edge) by using the three-finger technique shown above.

Sketching for Painting

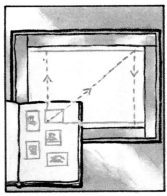

By overlaying your thumbnail as shown above, you can transfer its proportions accurately.

Problem: the increased proportions of the rectangle have been transferred accurately, but the contents have not been enlarged enough, leaving lots of empty space.

You could grid off your thumbnail and the paper, thereby transferring the internal proportions accurately.

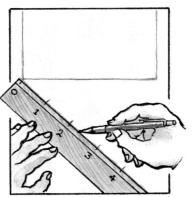

A fast way of dividing your grid, without excessive measurement, is to draw a line from one corner with easily measured divisions.

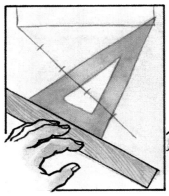

Then join the other end of your measured line to the other corner of the rectangle edge with a set square. Support the latter with your ruler.

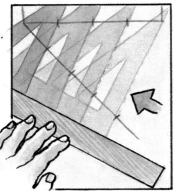

By sliding the set square along the ruler you can transfer equal divisions from your measured line to the edge of your rectangle.

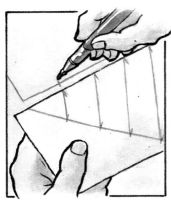

For tidiness you can do this measurement on the edge of a separate sheet of paper and then transfer it onto your work.

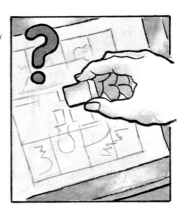

Problem: grid has to be removed or covered. In oils this is fine, but watercolours are transparent and grid shows through; trying to remove can cause paper damage.

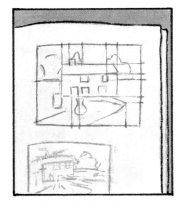

An alternative is to imagine (here drawn) lines extending from key points in your thumbnail to edges of the rectangle. The proportions are easily judged along these edges.

For transfer to the larger rectangle around your work . . .

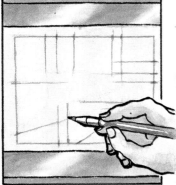

these points can be extended lightly inside the rectangle producing a loose grid.

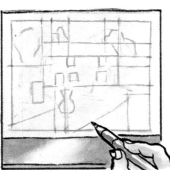

The drawing which follows, controlled by the grid, has the same proportions as the thumbnail.

For drawing on watercolour paper use a 0.5mm (2B lead) automatic pencil held lightly at the end.

This allows your drawing to be loose. Again, think of it as a scribble so you don't make the lines too strong.

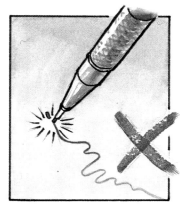

If you exert too much pressure, the thin lead snaps. This prevents the linework becoming too heavy and difficult to erase.

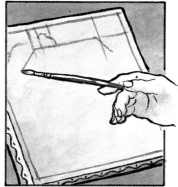

When using oils, hold your brush with this same loose grip when transferring your thumbnail to the canvas.

A putty rubber can be kneaded into shape for the controlled removal of lines and doesn't damage the paper surfaces.

Remove excessive linework either by dabbing it gently or rubbing vigorously with the putty rubber. By selectively removing certain areas you are drawing as well as cleaning.

If further drawing is required you can now achieve more control on your pencil by moving your grip lower down the pencil shaft.

The same applies as you add more detail to your oil painting, simply hold the brush further down the shaft.

There are no rules as to how much drawing is needed, but too little will not give you the confidence to start your painting.

Too much will result in an over-cautious approach when applying the paint for fear of losing the drawing.

If the line is to play an important role in the finished piece you can achieve absolute control by holding the pencil very near its point.

In painting, this sort of brush control is not usually required until near to the completion of the work.

Sketching for Painting

If you have the time, it is better to do your thumbnails on the spot, even on the back of an old envelope, a scrap piece of paper or in a sketchbook.

If you don't have time to paint your composition there and then you could take photographs to record the detail indicated in the thumbnails.

If your photographs prove disappointing you will still have your thumbnails to remind you of the dramatic elements of the view which excited your interest in the first place.

If you do have a little extra time and/or no camera, you could enlarge your preferred thumbnail.

Block in some shading with the side of a 2mm automatic pencil or a graphite stick.

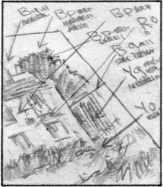

If you have time, make some colour notes to the side of the sketch.

Why not carry a few watercolour pencils with your sketchbook?

These could be used to add colour to your sketch as well as shading.

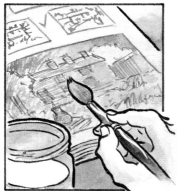

Running a damp brush across the pencil marks either on the spot, or later at home, fills in some of the white spaces.

Watercolour pencils are not a substitute for watercolour and the texture of the cross hatching shouldn't be lost. They can also be used under and over watercolour itself.

Using simple materials and creating simple sketches can be an invaluable way of gathering information in changing light or weather conditions.

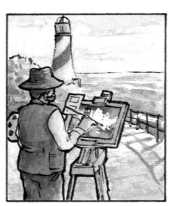

You could then return to the same spot with your sketches, under better conditions to continue your painting.

For really loose sketching you can enjoy the soft qualities of charcoal.

If watercolour is applied, charcoal will tend to smear. This can be advantageous or a nuisance.

However, you can apply fixative before you add colour, using an aerosol or mouth diffuser (see page 55).

The charcoal can be intentionally smeared or blended using a rolled or compressed paper stub (blender) which you can buy or . . .

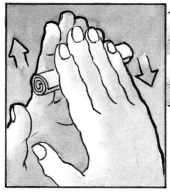

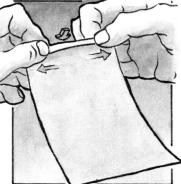

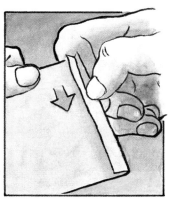

. . . you can make your own using blotting or sugar paper. Start by rolling a piece of the paper approximately 15cm (6in) by 7.5cm (3in) around a pencil.

Remove the pencil and roll the paper between the fingers to soften and curl it.

Open up the roll and crease back 6mm (¼in).

Run a nail along the centre of this fold . . .

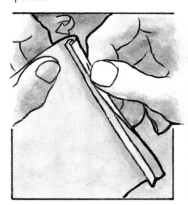

. . . and turn the paper over on itself tightly. This is the centre of your stub.

Begin rolling again. The tighter it is the firmer the stub. It rarely rolls evenly so the point is formed naturally.

A piece of sticky tape keeps the stub rolled tight. Tidy up by folding base and fixing to side with tape.

When using oils, many people draw out the outlines in charcoal first. Before painting either fix, or flick off, the excess charcoal with a soft cloth.

Watercolour Painting

Watercolour is a hugely popular medium. This comes as no surprise when you consider that most people start with simple pencil sketches which they overlay with colour washes of watercolour. This is actually the most basic of the watercolour techniques known as line and wash.

In the following pages I have outlined the three main methods by which watercolour is applied, beginning with line and wash, then going on to wet on dry, wet on wet and finally how to use a combination of these techniques. If you find yourself absolutely hooked on this medium then you will find more detailed information on all aspects of watercolour in my book *Art Workshop with Paul Taggart: Watercolour Painting*.

As I have already said, line and wash is the most basic of the watercolour techniques and within this particular discipline there are a multitude of possibilities to be explored. The quality of the line is all important and one of the most exciting aspects of this approach is the way in which this line can be varied. For example, if you use a chinagraph pencil or charcoal for your linework, you will produce a soft dense line whereas a hard-leaded pencil will give a fine faint line. The watercolour itself can be used to produce coloured lines or black ink to give another variation – the possibilities are endless. The linework can be as solid as the lead around a piece of stained glass or as fine as the strands of a spider's web. As the strength and weight of the line varies so we can change the depth of colour laid over and around them.

Many artists work within this field alone, exploring all its inherent beauties. However, you may come to a point where the colour begins to dominate and eventually the line disappears. Once you have reached this stage, you have, in my view, entered the realms of true painting and are ready to tackle the technique known as wet on dry.

The approach to this technique is quite easy as it seems most natural to work the wet paint onto a dry surface (hence the name wet on dry). The most distinctive characteristic of this technique is the hard sharp edge the paint creates as it dries. It is important to keep the brushwork light and fresh so that the clarity of the paint's edges is exploited to the full. If you find the edges too

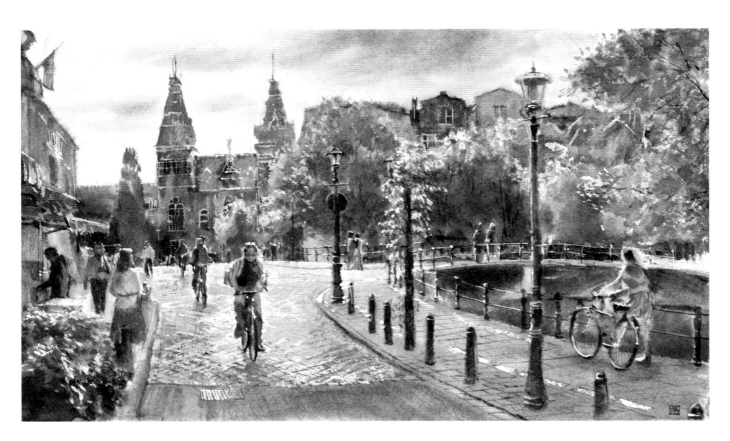

harsh, they can be softened or 'lost' with a damp brush; or broken up with scumbles and other dry paint techniques (see pages 38–39). The great variety of techniques available within this field give the paint's surface a wonderful richness and depth.

Now we move on to what I consider to be the ultimate watercolour technique that of wet on wet, whereby the paint is worked onto a wet surface. It is the most difficult of all watercolour techniques to master, requiring practice until you have mastered its many subtleties. The fluidity of the brushmarks produced and the richness and depth you can obtain by using the paint almost straight from the tube is unmatched by any of the other techniques.

It is the goal towards which most ardent watercolourists aspire. Once you have learnt to control the flow of paint on the wet surface, I guarantee that you will never lose your sense of awe and excitement at the results which can be achieved.

As you will have gathered, there is a natural progression through the watercolour techniques from line and wash to wet on wet. It is best to work through them in this order which will ensure you acquire an overall awareness of the versatility of the medium. You may decide that you would like to specialize in one particular aspect of watercolour, or you may change your technique to suit your subject, or like myself, you may prefer to combine the techniques. My own personal preference is to work with two layers of wet on wet and then finish with a final layer using the wet-on-dry technique.

It is worth mentioning here the number of layers to use. Of course it is wonderful if the paint works immediately and the desired result is reached using only one layer, giving the surface that wonderfully transparent glow unique to watercolour. Generally speaking, however, the depth of colour and/or textures required can only be achieved with several layers of paint. As a general rule I try to produce my watercolours using no more than three layers. If you start using more than this the paint tends to become too heavy and loses its translucency. There is also the danger that underlying layers will be disturbed and become 'dirty' through overworking. A limit of three layers, while not being an absolute, is a good discipline.

I usually allow the painting to dry out between each of the three layers. However, some artists like to work at such speed that wet-on-wet marks used in the distance begin to sharpen as they work through the middle distance. By the time they reach the foreground the painting is dry and the hard edges of the brushmarks suggest focus. Thus, with only one wetting, a natural depth in the painting can be achieved. Whilst very exciting, painting at this speed requires great skill, timing and above all, courage. Have a go yourself, it will help to build your confidence and bring fluidity to your work.

The combination of techniques I use aims to emulate the way we actually see things. The next time you start a painting consider the way in which you are viewing your subject matter. You may think you are seeing everything at once, but in actual fact your eye is constantly darting from one object to another as it can only focus on one object at a time through a tiny 'window' of focus. Just try for a moment to keep your eye focused on one spot and try to make out the details around it. You'll notice that the clarity of detail diminishes in direct relation to how far away it is from this window of focus.

A painting should echo how we see things by focusing our attention on specific details and simply suggest the remaining forms using simplified blocks of colour and tone. By using this soft-focus approach you avoid the startlingly surreal look obtained if everything is given the same detailed emphasis.

In my paintings the first two layers of wet on wet give a soft, suggestive feel while the final layer of wet on dry brings sharp focus to those areas I wish to emphasize.

The artstrips and step-by-step paintings which follow describe in detail the way in which I combine the techniques and how the three layers are built up. Read the whole section to give yourself a feel for the entire process, but don't be alarmed by the amount of material covered. It has taken me years to master all these techniques so don't expect to be able to remember or master them in just a matter of hours.

If you copy one of my paintings, don't feel you have failed if your finished piece looks totally different. This is as it should be and shows that you are bringing your own unique view and approach to the medium. And one final word of advice when using watercolour, its beauty is reliant on its natural transparency so always aim to work fairly quickly with fluidity to avoid overworking. Watercolour is a fresh and exciting medium and one which I hope you will enjoy working with.

Watercolour Painting: Materials and Preparation

WATERCOLOURS Always buy the best materials you can afford as in the long run you will be saving yourself money and time. This means buying tubes of Artists' quality watercolours which contain purer pigment and less filler or bulking agents than the Students' quality paints. The colours achieved with Artists' quality paints are much richer and the colour mixes obtained much purer. Used almost undiluted on a wet surface they give a wonderfully rich lustre. On a practical note, the Artists' quality paints are easy to re-dissolve if they have dried out on your palette whereas the Students' quality paints are slower to re-dissolve and rubbing them with a wet brush not only wastes times but also damages the brush head.

Pan colours are blocks of solid dry paint (also available as Artists' quality and Students' quality colours) and are excellent for detailed work where only a small amount of colour is required. If you want to cover a large area with a wash then it is better to use tube colour. Again, I would buy the Artists' quality pans of colour for the same reasons given above.

PAPER Do buy watercolour paper. I have seen many a student struggle with a sheet of cartridge paper thinking that their lack of success was due to their inability to paint. This was not the case, the paper simply wasn't good enough. Most watercolour paper is rich in size which means it will stay wet longer and allow you to remove

paint without damaging the surface while ordinary paper would simply disintegrate. The former comes in a variety of weights which basically equate with its thickness so the heavier the paper is, the thicker it is. The general rule is that the wetter you are going to make the surface, the thicker the paper you will need. So for line and wash you can use a lighter paper than if you are attempting wet on wet. It's worth remembering though that you can never buy a paper too thick for your requirements but you can buy one that's too thin.

Papers also come in different textures from the smooth papers known as Hot Pressed (HP), through to NOT or Cold Pressed (CP) papers and on to the most textured papers, known as Rough. The most popular paper for beginners is the NOT, but most watercolourists eventually use the Rough which gives more interesting textures. I used a 300gsm (140lb) Rough paper for all the paintings shown on the following pages.

BRUSHES There are a huge number of brushes to choose from and every artist will develop his or her own preference as they become more experienced. However for the beginner I would recommend buying a number of round, natural-hair brushes (see page 127 for the exact sizes). If you can afford it, buy pure sable, but otherwise a sable and ox hair mix, a sable and nylon one, or failing that a nylon one. Avoid squirrel-hair if you can as I find it too

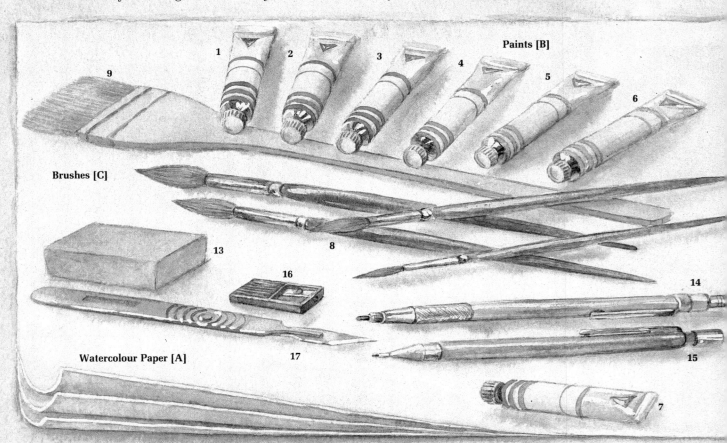

Paints [B]

Brushes [C]

Watercolour Paper [A]

soft and blunt to be of much use.

Finally you will need to buy a 44mm (1¾in) hake which is an essential piece of equipment if you are planning to employ the wet-on-wet technique. This is made from soft goats' hair and must not be mistaken for a large flat bristle brush which is similar in appearance but considerably harder. The hake can be used to apply paint but its overriding asset is that it can be used to apply large quantities of water smoothly and evenly over large areas including areas of dry paint without disturbing the pigment.

PENCILS You will need a soft 2B pencil for sketching in the initial outlines of your painting. I would suggest buying one of the modern clutch pencils with a 2mm lead which can be sharpened (with a special sharpener) to give a lovely long point which would be difficult to achieve on a conventional pencil. You could also try an automatic pencil which is available with a 0.5mm lead so it doesn't need sharpening.

PALETTE You will need a palette – a plate simply won't do as all your colours will run together. You can now buy plastic moulded palettes which provide deep wells for the fluid mixes and a flat surface for the stiffer mixes needed when using wet on wet. You can, if you prefer, buy separate palettes for the different types of mixes but the combination palette is the most economical.

DRAWING BOARD You will need a plywood drawing board on which to stretch your paper. It needs to be fairly thick so it doesn't warp or bend with use but not so thick that it is too heavy to carry. I have found the ideal thickness is 2cm (¾in) and instead of wasting money on buying a ready-made board you can easily have one cut to size. This also gives you the freedom to specify the exact dimensions of the board which should always be 5cm (2in) wider on each side than the largest piece of paper you plan to use, to allow for stretching.

EASEL As soon as you can, buy an easel so that you get into the habit of working upright. Working flat produces distortions, so even if you do not have an easel prop your drawing board up at an angle. You should position yourself so that your paper is alongside the subject you are painting so that with a flick of the eye you can move between the two. If you have to constantly crane your head to see your subject matter then you will soon tire and stop looking.

MISCELLANEOUS A good kneadable putty rubber is essential for removing linework, rubbing and lightening areas. An ordinary rubber will not do as it will damage the paper surface.

A good supply of very absorbent tissues or kitchen roll is also invaluable to remove water quickly from the paper surface or your brushes.

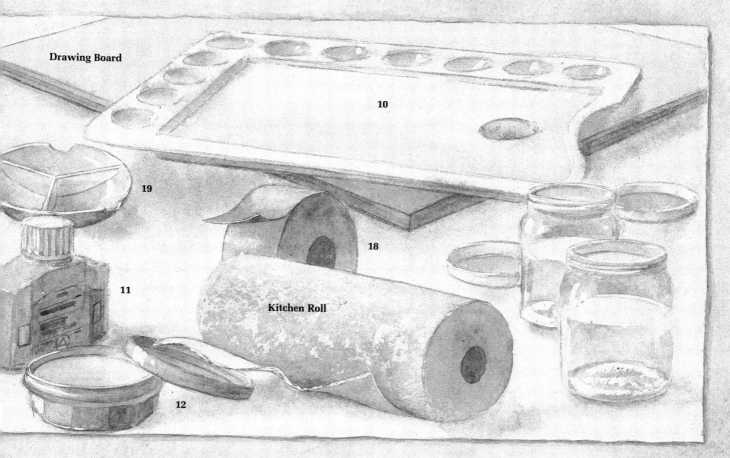

Drawing Board

10

19

18

11

Kitchen Roll

12

(See list of materials on page 127 for key to numbers)

Materials and Preparation

Caring for your materials

It's worth looking after your materials as not only will they last longer but they'll produce better results. Brushes, in particular, can easily be damaged, especially if you don't wash them thoroughly after a painting session. The best way to do this is to swill them off in clean water and work the head over a bar of soap or brush cleaner. Use your nails to work the soap into the very base of the brush head where paint often accumulates. Wash under cold water and repeat the process until no more colour can be seen in the rinsing water. Never use hot water to clean your brushes as this damages the hairs, expands the metal ferule or ring which holds them in place and can even melt the glue, which means the hairs will fall out. When the brushes are clean, reshape the head with your fingers and stand upright in a jar to dry. It's worth storing your brushes with a few mothballs as it's quite amazing the damage these little creatures can inflict upon brushes.

Never stand your brushes head-down in a jar of water. They will lose their shape and you'll lose all control when trying to use them. When carrying them around, buy a tube or roll to protect the brush head.

If your brushes are bent out of shape, they can be saved by working soap into them as if you were cleaning them. This time, however, keep going until the hairs become stiff with the soap so that you can then shape the brush back to its original form. Leave the soaped brush to dry out for at least 24 hours and then remove the soap by soaking the whole brush in a basin of cold water until the hairs loosen up again. Never bend the brush head or try and remove the soap when dry as you will damage the hairs.

Your paints also need to be looked after. Never leave the cap off a tube of paint for longer than necessary as paint will begin to harden inside the cap and it won't fit the tube properly. If this happens the paint in the tube will start to dry out. If you find you cannot remove the cap from a tube, hold the cap under a hot tap as this will make it expand and you should then be able to loosen it.

Avoid twisting and tearing the tube when trying to remove the cap by tightly rolling up the bottom of the tube. This keeps the tube taut and prevents splitting as you unscrew the cap.

If the paint in the tube has hardened remove the cap and drop both into a jug of cold water and leave for at least 24 hours. At the end of this time the colour inside the tube and the cap will have softened.

Starting off tips

Don't scrimp on the amount of paint you use. There should be enough colour in the wells of the palette to allow you to dip your brush in without touching the bottom or sides. This is important as if the brush is carrying another colour it will not deposit any in your clean colour.

You needn't worry about wasting the paint as you can leave it in the palette and next time you start a session, simply cover the colour with a film of water and it will quickly re-dissolve (especially if you are using Artists' quality paints).

If your paper is particularly well sized you may find it's reluctant to accept the paint or water which will accumulate as droplets on the surface. This can result in an effect known as pigskinning whereby the paint forms a textured layer on the surface rather than a smooth wash. To avoid this add a few drops of Ox Gall to your water or paint, this acts as a water softener and allows the liquid to flow more easily.

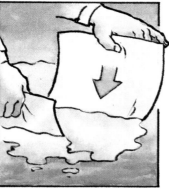

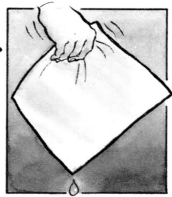

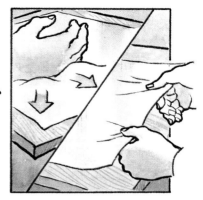

Stretching paper: all paper cockles when wet, making painting difficult.

To overcome this problem, stretch the paper by dipping it in water. Thicker papers need more soaking than thinner ones.

When the paper has thoroughly absorbed the water, run off excess until dripping stops.

Place on an unpainted, unvarnished drawing board. Remove any large air bubbles gently by hand or by pulling.

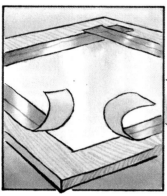

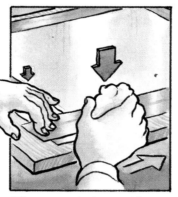

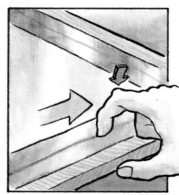

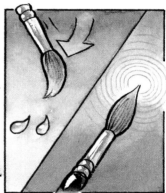

Wet some pre-cut lengths of gumstrip and stick the paper down on the board so that half the gumstrip covers the paper and half secures it in place.

Wipe gumstrip down with tissue paper to force out and absorb any water leaking from beneath the gumstrip. Use other hand to hold the gumstrip in place.

Run finger nail along the paper edge to ensure maximum adhesion. Leave flat until the paper is dry and stretched. Only remove when painting is complete.

Brushes: when buying round brushes check quality by dipping each one in water (ask shop to supply) and giving a sharp flick. They should form into a point.

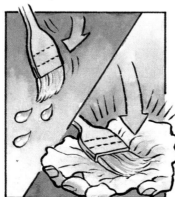

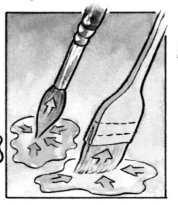

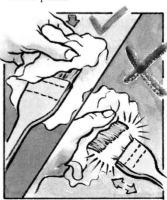

A brush without this quality will lack the necessary control for painting.

The flicking motion can be used to dry other brushes, e.g. the hake. Try also slapping it onto a tissue to remove excess water.

A 'thirsty' brush like this will soak up excess water or paint from the paper surface.

The hake can be dried further by squeezing it between some tissue. But never pull the hairs.

Watercolour Painting: Starting Off

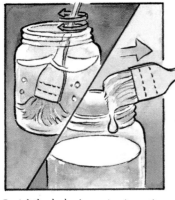

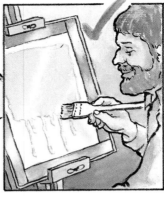

Swirl the hake in water to wet thoroughly. Touch edge of jar with brush head to stop water dripping but keep brush well loaded . . .

. . . so that the water can be applied heavily in horizontal strokes. Coverage is then fast and efficient.

As soon as the coverage becomes patchy, rewet the hake and continue.

Don't worry about applying too much water. If you work upright, the excess runs off naturally.

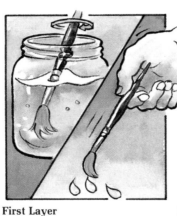

The water will soak into the paper fibres while you mix your first colours.

First Layer
You are now ready to apply your first layer of wet on wet. Take your largest round brush and wet it thoroughly; flick to remove excess water.

Dip this damp brush into the centre of wet colour squeezed directly from the tube. Collecting colour in this way will not soil your pigment even if the brush is dirty.

Transfer the paint to a flat area of the palette and pull out into a thin layer.

This smooths out the paint on the brush head and also flattens the brush into shape.

Meanwhile, the paper will have lost its sheen of wetness as some of the water will have been absorbed by the paper and some evaporated.

So you will need to rewet the whole surface with the hake.

Then, using the round brush, block on areas of light colour. Use the side of brush head for this first application.

The paint needs to be fairly stiff so the colour stays in place.

If it is too fluid, it will explode across or run down the surface, depending on the angle of the board.

The amount of pressure you exert on the brush head as you apply the paint will result in differing depths of colour.

Using the shaped, chisel end of the brush it is possible to create fine soft lines of differing tonal strengths.

You may only wish to apply the colour as a light wash.

In which case the colour may be mixed with more water in a well or corner of the palette (this is the density of mix most people expect of watercolour).

Test the mix on some dry paper. Keep brush on surface and use side of brush head. This will show the maximum tonal value possible with a thin layer of the mix.

If too much of this thin colour is applied, it will explode across the wet surface.

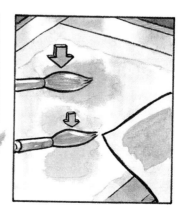

Therefore, remove excess colour from brush either along the palette edge or on an absorbent tissue.

The brush cannot be shaped as before as the thin paint allows it to bounce back to its natural pointed form.

Test for colour depth and fluidity by dabbing the surface gently.

The thin colour can now be applied. The colour/pressure relationship still holds, but the strength of colour will not exceed that of your dry-paper test (see *above*).

Starting Off

The most natural place to start painting, the top, is also the most sensible.

If the colour runs it will not ruin an area you've just painted, and can easily be dabbed off with a tissue.

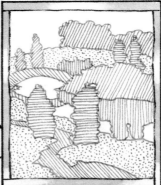

The top of the painting usually portrays the most distant objects. As you move forward you can overlap the masses, giving a feeling of depth.

Your paper may dry before you have finished. If you continue you will produce the hard edges associated with working into a dry surface. Stop immediately.

Rewet the area that has dried out with the hake.

If you rewet the just-painted area this heavy wetting may cause a resist known as a backrun (or cauliflower).

To avoid this remove any excess water from the hake by giving it a gentle flick.

You can now safely rewet the painted areas although a little extra pressure may be needed to wet it sufficiently.

If several colour mixes are required, the surface may dry before you finish, resulting in a patchy appearance.

These areas can be painted having allowed the surface to fully dry. Rewet at least 2.5cm (1in) beyond the area to be covered.

This avoids the hard edging of new paint. As you are still covering raw paper, count this second wetting as part of your first layer.

Applying light colour washes often acts like a rewetting and further colours can be added into them. Still count this as your first layer.

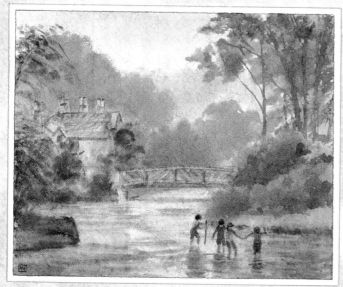

The colours in this study were deliberately kept muted to emphasize the tonal relationship between the elements of the composition. Squint your eyes and they will become even more obvious. The tonal accents (dark areas) deepen as you move towards the foreground, even those on the water surface. Colours were warmed up gradually as they came forward. Working from the rear of the composition each mass or plane was laid over the former, which enhances the feeling of depth. The darkest accents of all are found on the objects nearest to the viewer which in this example are the children.

The simple power and beauty of a graded wet-on-wet wash was employed for this winter's sky. This simple composition depends for its effect on the contrast between the warm yellow/orange areas of light and the cold blue/purple areas of shadow. Here again the darkest tones in the painting, the figure and tree to the left, become the foils against which the eye judges all the other tonal relationships.

Here the softness of the wet-on-wet brushmarks gives both movement and depth. These soft marks, lacking the definition afforded by a sharp edge, rely for emphasis on tonal strength alone. Therefore you must be bold when applying the colour and make sure it is strong enough, especially as watercolours lighten when they dry out.

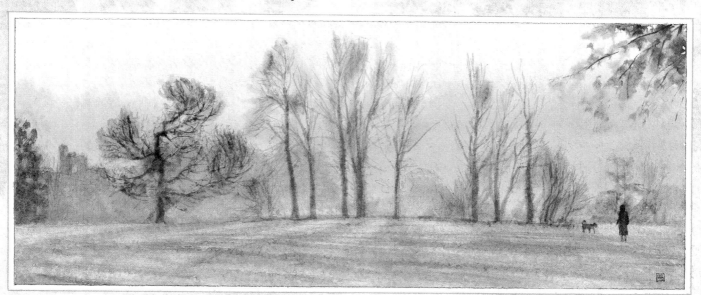

Watercolour Painting: At Home

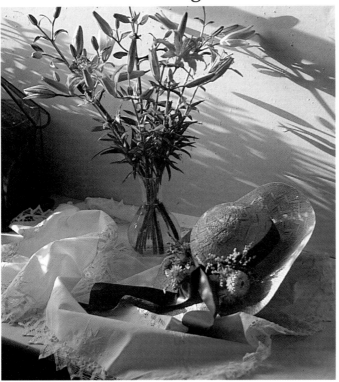

Still-life painting can be tremendously exciting. However, I know from experience, that many people shudder at the mere mention of the phrase, no doubt recalling memories of dusty wine bottles standing in the corner of school art rooms – their first introduction to still life. Personally, I'd fall asleep if I had to paint an empty wine bottle, but a beginner faced with this situation often feels it's their fault that they're not inspired. But believe me, still-life painting isn't boring; you can take risks with it which can keep you on the edge of your seat, so don't dismiss it because of bad experiences in the past.

The first thing I look for in my arrangements is a variety of textures. Here we have a combination of glass, straw, flowers and fabric. Each will have to be treated differently, but the group as a whole will be held together by the effects of the light. This is probably the most important element of all and although it cannot be collected, you can arrange your objects so you gain maximum benefit from it. Look at the light on the wall behind the flowers. This photograph was taken at 6.30 in the morning and it stayed in that position for about 20 minutes. Without it there would have been a big empty nothingness in the top right-hand corner of the painting. Sometimes it's impossible to paint quickly enough to capture such dramatic light effects, so you must take fast drawings or use a camera. There is great drama to be discovered in painting objects and you may even ask yourself 'Is a Still Life really ever still?'

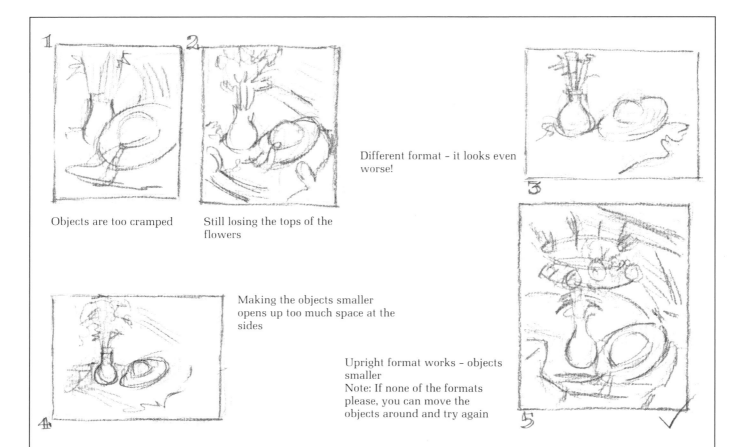

1 Objects are too cramped

2 Still losing the tops of the flowers

Different format – it looks even worse!

Making the objects smaller opens up too much space at the sides

Upright format works – objects smaller
Note: If none of the formats please, you can move the objects around and try again

It is not only important to move your objects to get the best arrangement, but to move yourself around until you find the best spot from which to view them. Here I found that the best view was achieved by standing.

Although this was my first layer, the surface had already dried out. I rewet certain areas so I could apply further wet-on-wet colours. The orange and yellows of the flowers were applied first using very stiff paint. While they dried, I added several layers of colour to the hat, from light orange to mid brown. The warm and cool greens of the leaves and vase were then added. This interplay between warm and cool colours was continued in the portrayal of the fabric. Although the fabric was actually white, tonally it was much darker than the bright highlights on the flowers and hat, etc. You must also consider that any colours placed on now will look much lighter when darker accents are introduced. A final application of green and yellow washes to the hat completed the first layer of wet on wet.

By the time I had transferred the drawing to my water-colour paper the sunlight on the wall had disappeared. My drawings were therefore of great importance as they would have to remind me of the play of light. Note the circular path I traced through the fabric, round the hat, through the shadows and up round the flowers. A reading lamp placed to the left of my grouping provided enough light to emulate the bright sunlight that had lit the back wall, parts of the fabric and flowers. I protected these areas with masking fluid and when dry overlaid them with warm and cool wet-on-wet washes.

Once the surface was dry, the masking fluid was removed with a putty rubber. Where these areas looked too sharp, for example, on the fabric, I softened the hard edges using the lift-off technique (see page 32). I also felt the structure of the fabric edge in the shadow of the hat needed more emphasis, which I achieved through lift off.

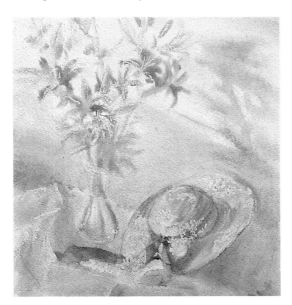

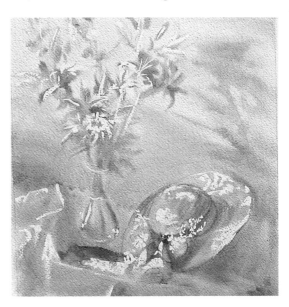

(Continued on page 34) 27

Watercolour Painting: Out and About

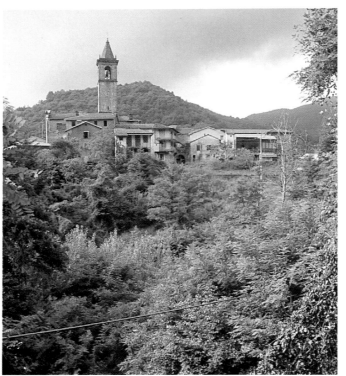

I glimpsed this view of an Italian village when passing by in a car and had managed to stop for 10 minutes to complete a series of thumbnail sketches. The view was magnificent. The warm colours of the buildings contrasted with the lush green of the valley below and all were framed by the vines looping between two trees at the side of the mountain road. The afternoon sun was slanting in from the right-hand side, opposite to the angle you see in the photograph which was taken in the morning. I made a note of all this in my sketches. I didn't have time to take them any further but I had enough information to assure me that a painting was possible and a few days later I returned with all my equipment, eager to begin. Fortunately, the humid heat of the previous days had been relieved by a tremendous electric storm the night before. The weather was therefore much cooler, perfect for the job in hand.

(*Opposite page, top left*) Although I was standing on the roadside, I was in a safe position away from the precipitous edge and in full view of the traffic. In fact some cars stopped and the occupants unloaded to see what I was up to. Not only did I meet many of the local inhabitants, but many asked if the painting was for sale. You may be a little nervous of such attention, but if it brings an instant market for your work it may be worth the effort. Note the carrier bag fixed to the leg of my easel ready to take my rubbish.

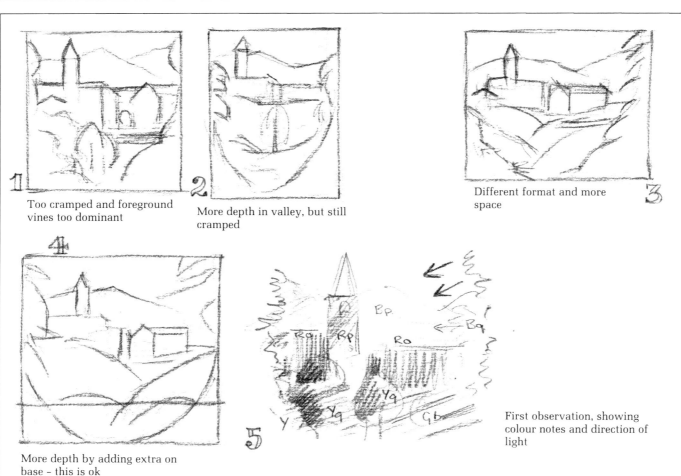

1 Too cramped and foreground vines too dominant

2 More depth in valley, but still cramped

3 Different format and more space

4 More depth by adding extra on base – this is ok

5 First observation, showing colour notes and direction of light

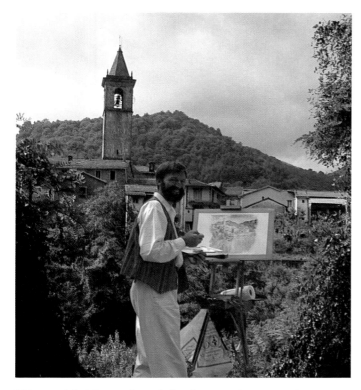

(*Above right*) I transferred the drawing from my chosen thumbnail and applied masking fluid extensively. This was to separate off areas as well as to protect highlights, for example, the foliage from the sky and the roofs of the buildings from the hills. The foreground trees were kept separate by masking off highlight areas along their top edges. A dead bleached tree on the right was also masked and some diagonal scumbles laid across the bank beneath the buildings, so I could later suggest sunlight catching the grasses here. The area of light coming through the bell tower was also protected as this would become an important detail later.

(*Below left*) Having wet the whole surface, I applied a phthalo blue to recreate the intense colour of the Mediterranean sky. I then used a yellow-green for the distant hills and, while still wet, textured those on the right with pure ultramarine. Proceeding forwards, I continued to apply yellow green using it directly behind and beneath the buildings. The greens in front of the buildings moved from this strong yellow green, through middle greens to the grey greens on the left.

(*Below right*) Once dry, I rewet the area around the buildings and painted over them with a light orange. Even though I'd rewet the surface, I still considered it as part of the first layer as the paper here was receiving its first layer of colour. The vines were then rewet and painted using yellow green at the top, middle green for the central area and very warm greens at the bottom. Returning to the buildings, I rewet them once again and applied a generous wash of middle orange to identify the main shapes.

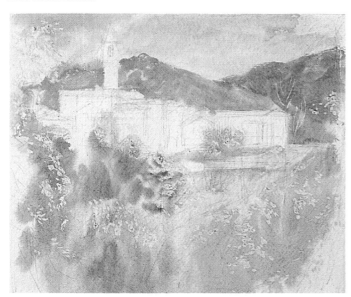

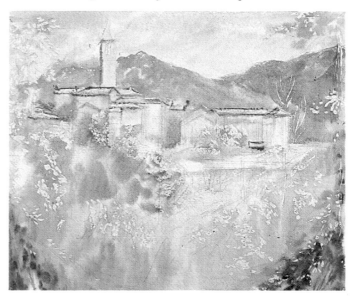

(*Continued on page 36*) 29

Watercolour Painting: Techniques

Second Layer
Check for dampness, with back of fingers, against an area you know to be dry before continuing with the second wet-on-wet layer.

A damp area will feel cooler and will grip the fingers slightly if you gently move them from side to side along the surface.

The colour may look dry but even if it's slightly damp it will lift off, or become textured, if rewet too soon.

Rewet only a small area which can be completed before it starts to dry out as applying more water to a damp area can cause paint lift.

Wetting a small area ensures the intended reworking can be completed before hard, dry edges begin to occur.

If the hake is too dry, excessive pressure is required to ensure coverage, and the resulting friction may lift the first paint layer.

If the hake is not picking up enough water, try working it well against the base of the water jar and/or add a few drops of Ox Gall (water softener) to the water.

For maximum load, without drips, wipe the hake gently against rim of water pot. If a little less water is required, flick it very gently.

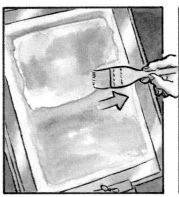

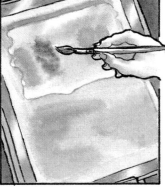

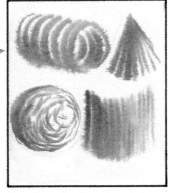

This fully loaded hake rewets smoothly and swiftly without paint lift, even over large areas.

Using your round brush, you can now work in the rewet section.

Note how the direction of the brushmarks are important in suggesting volume . . .

. . . and texture . . .

... and how the pressure of the brush can be employed to create shadow areas.

The first wet-on-wet layer blocked in the masses.

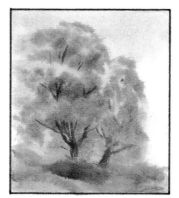

The second layer gave them character, contrast and structure.

Rewet small areas, one at a time, so they can be worked on separately, avoiding backruns and lift off.

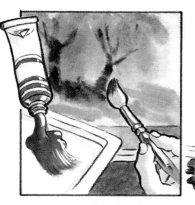

Dense areas of dark colours are now created by using paint almost straight from the tube.

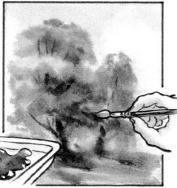

Overpainting colours from the same family creates intense dark areas, e.g. dark greens over light.

But also try overlaying complementary colours in the same areas, e.g. purple over yellow greens is one of my favourite combinations.

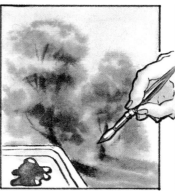

If the wet-on-wet brushmarks bleed excessively . . .

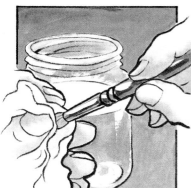

. . . squeeze a clean damp brush on a tissue, taking care not to pull the hairs.

This thirsty brush will absorb any excessive paint run.

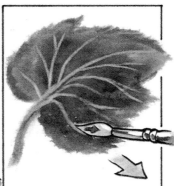

This technique can also be used within paint areas to create soft lines and highlights.

If the paint will not lift, rewet small sections with a clean brush and attempt the lifting process again. More paint comes off if you then dab with a tissue.

Techniques

If you want to create sharper highlights, apply some latex masking fluid between paint layers. This will act as a resist.

Wet brush with soap and water before applying fluid – this makes the brush easier to clean. Practise brushmarks on a spare piece of paper.

Avoid applying deep pools of mask which skin over and take a long time to dry.

Practise scumbling with the mask by dragging side of brush head over the paper to reveal its textures.

Scumbling gives shimmering broken highlights (*top*), rather than solid lumps (*bottom*), when the mask is removed.

Mask can be removed only when paint layer is dry. Use a putty rubber rather than your fingers.

On removing the mask some resists may prove disappointing while others may be too harsh.

Disappointing highlights can be improved by lifting off more colour once dry using a damp flat brush and tissue respectively.

Hard edges can also be softened in this way.

To reduce the colour or tone of a large area, rewet surface with the side of brush head. Don't rub.

Dab immediately with clean, dry, absorbent tissue. Rub fingers across tissue, not tissue across surface, for controlled lift off.

Repeat process until desired colour lift has been achieved.

The aim of this study was to employ as many wet-on-wet, or soft, textures as I could manage. To this end, once the composition had been filled in with light background colours, I rewet sections with a small flat nylon brush. Then, using the side of a round brush, stiff paint was scumbled into the wet surface. The paint had to be very stiff to achieve any kind of texture so, if you wish to experiment with this technique, be prepared to use colour at tube consistency.

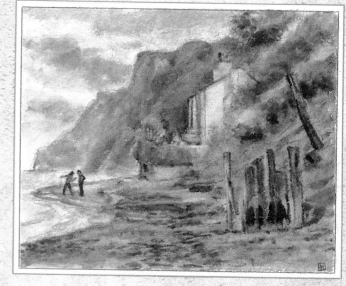

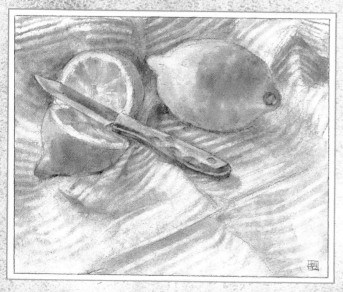

Here, volume was suggested by varying the tonal range of the colours. To achieve this the brush was loaded with very stiff paint and applied to the surface with varying pressure – the greater the pressure the deeper the colour. All of the edges are soft because the colour was applied wet on wet, although some of the white lines in the serviette were achieved with lift off, once the surface had dried. You can see here the compatibility of the lift-off technique with wet on wet.

The use of masking fluid to highlight the gulls and the foaming waves added sharp edges to this wet-on-wet study. Once the mask was removed, colour was dropped into these protected areas. Note how the use of yellow, suggesting the reflection of the sun, brings a sparkle to the water and forms a contrast to the cool blues applied to the reflected highlights on the waves. (See opposite page for a more detailed study of the techniques used here.)

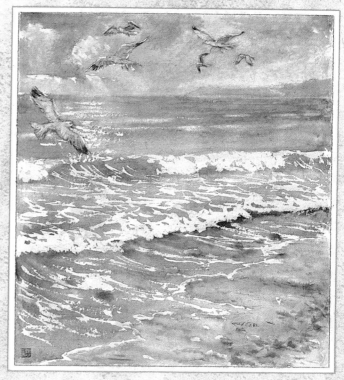

Watercolour Painting: At Home

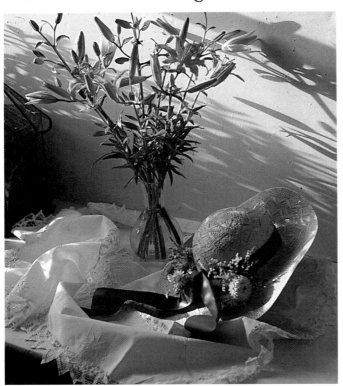

Directional lighting enlivens any still-life arrangement because of the dramatic contrasts it gives between the light and shadow areas. Natural light is by far the most effective and, if you can, set up your arrangement so that sunlight falls across it. A lamp can be used to mimic sunlight on a dull day. In the diagram below you can see that natural light is provided from a window to the left of the arrangement. The white surface on the far right provides reflected light which can bring colour and form to otherwise lifeless shadow areas. The easel is positioned to take advantage of the natural light and a handy table to the right holds all the materials within easy reach.

Do move the objects around while producing your first thumbnails to get the best grouping. You can stand or sit to paint but, if you can, observe through the use of your thumbnails how your eye level will affect the balance of the composition.

(*Opposite page, top left*) You can see here how I am trying to directionalize the light by using the window blind and a lamp as an artificial source of light. The board should really be positioned in front of the window to capture as much natural light as possible (*see page 26*), but because my studio walls are all white and reflect light well, I can usually get away with this. However, the weather changed and it became so dull that I did have to move my easel.

'Sketchbook' Techniques

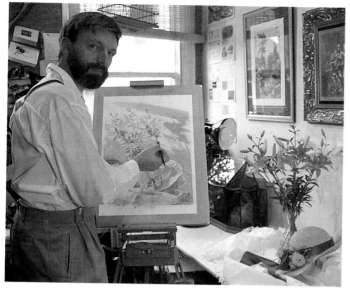

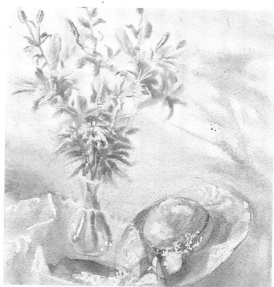

(*Above right*) The second layer of wet-on-wet colours was now applied by rewetting small sections only, having mixed the colours first. I began by applying a darker green to the foliage and stems of the flowers. I then concentrated on the highlight colours and dropped light yellow tones into the previously masked areas on the hat and, to give more contrast, darkened the shadow areas. Similarly, the previously masked areas of the flowers were now painted with bright yellows and oranges which were echoed in the more subdued highlights I added to the fabric below. The ribbon and flowers on the hat were similarly brightened and, once this was completed, nearly all of the white paper had been covered with colour.

(*Below left*) The application of paint now turned to wet on dry. I really wanted to emphasize dramatic play of light on the wall behind the arrangement so I freely splashed a yellow grey across this area. While it was still wet a darker

version of this colour was dropped into sections for extra contrast. A cool grey, in a similarly loose manner, was applied to the fabric using my largest round sable brush. Note the sharp edges this begins to create against the hat, vase and folds of the cloth.

(*Below right*) I continued the sharp focus effect of the wet-on-dry layer on the green foliage and flower heads. It is essential to keep the brushmarks fluid so you have to apply the colour quickly. If you ponder over detail you will undoubtedly overwork the area. I felt the flowers were beginning to dominate the picture, so to counterbalance their power, I increased the tone of the background by applying a blue grey. This was the darkest tone I could achieve without the colour becoming dirty. Again, the colour had to be laid quickly to avoid lifting previous layers. Some of this dark colour was also applied to the vase to express its transparency.

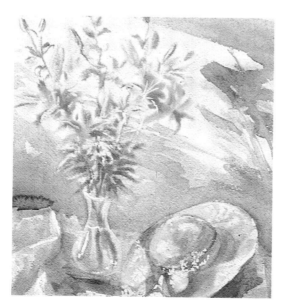

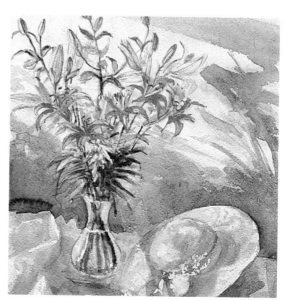

(*Continued on page 42*)

Watercolour Painting: Out and About

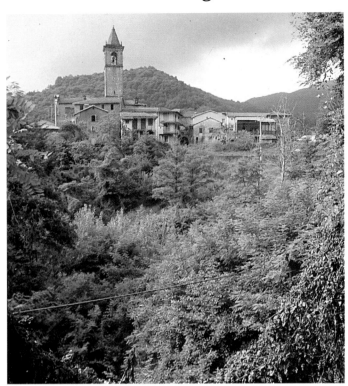

In a clear sky the blue becomes lighter towards the horizon, an effect that can be created using a graded wash (1). If you introduce clouds, don't let this affect the smooth gradation of colour as you paint around the clouds (2). In this way, the blue sky falls behind the clouds. Sunlight is yellow and therefore the 'white' lit side of the cloud should be overlaid with a light-yellow or orange wash (3). The depth of shadow tone beneath the cloud depends on its thickness. The grey can be created with the blue from your sky and the orange of the sunlit cloud (4). Note how generally the bottom of the cloud is flat and the top more sculptured. Before the two colours dry, rinse your brush and squeeze out any excess water with your fingers (5). Don't squeeze too hard or you will get a 'thirsty' brush. Use this brush to feather the sunlight and shadow together to give softer edges (6).

(*Opposite page, top left*) The day was beginning to heat up, so it was on with the hat. You'll find wearing a hat not only protects your head, but also your eyes. On a bright day like this, much of the overhead glare from the sky was cut off by the wide brim of my hat, making the process of concentration a lot less tiring, as I didn't have to keep squinting into the sun.

'Sketchbook' Techniques

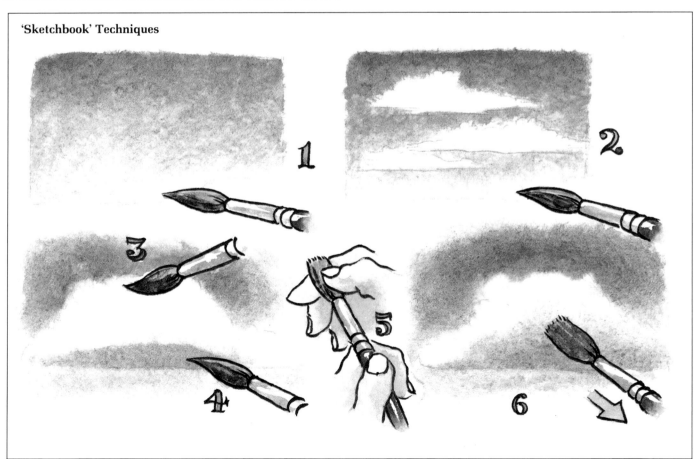

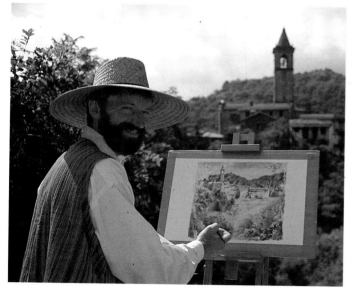

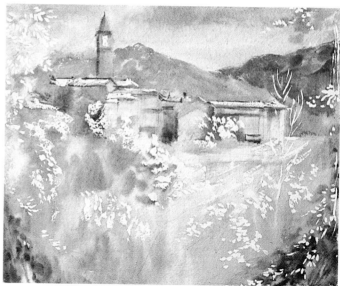

On very hot days I even wet my hair periodically, and then replace the hat, to keep the temperature down. As the sun moves, you may find it shines across your paper. The glare will blind you and throw out all your colour balance. You must either move your easel to avoid the sunlight, or carry a large umbrella to shade the work.

(*Above right*) Some warm and cool washes were taken across the buildings to solidify them and give some contrast. The surface quickly dried in the warm breeze, allowing me to remove, with a putty rubber, all the masking fluid I'd previously applied.

(*Below left*) I rewet the hill directly behind the buildings, stopping exactly at the roof edges so the paint flow was restricted. The tree-covered hills each side of the church tower were then rewet individually and purple shadows and textures were blocked in. In front of the building I

applied a yellow-orange wash to the masked tree highlights to suggest the light of the afternoon sun that I had seen when first encountering this view. Moving towards the bottom right, these highlights became cooler and bluer as they were the result of reflected light rather than direct sunlight. Dark olive-green shadows were laid heavily in the top left foreground area. Dropping into the valley depths, these dark tones became cooler.

(*Below right*) The vines on both sides were rewet individually and the previously masked areas received some yellow-green highlights. While still wet, I introduced some middle greens and line details of the vine shoots. Towards the base of the vine these accents again became warmer with the addition of red to the Prussian blue and yellow mix. The vines, although framing the entire view, are slightly irregular, the one on the right being wider. This gives a more natural feel to the cameo.

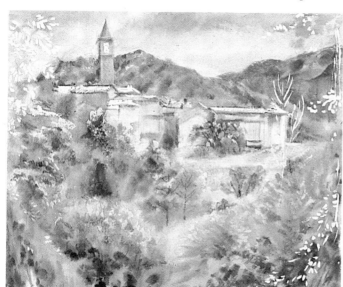

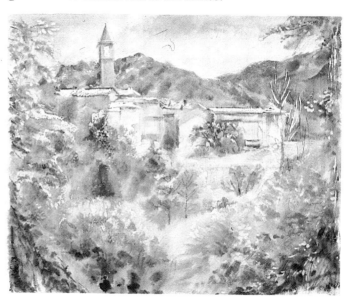

(*Continued on page 44*)

Watercolour Painting: Finishing Off

At home, use a hair dryer to speed up the drying time between layers. You can learn a lot about the changes of tone that occur by watching paint dry.

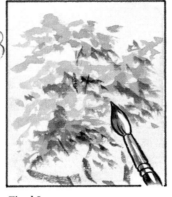

Final Layer
The final layer is applied wet on dry. This technique is distinguished by it's sharp-edged brushmarks and thin transparent colour.

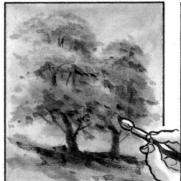

This brings focus to the soft marks of the wet-on-wet layers beneath.

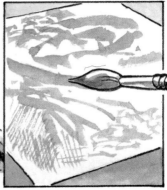

Practise your wet-on-dry brushmarks on a spare sheet before committing them to your painting.

Time and paint are saved if you use two round brushes, one slightly larger than the other.

The small round one can be employed to mix and apply the colour. Note: mix colour in well of palette to hold the more fluid paint.

The larger brush should be soaked and excess water gently flicked away. Practise will teach you how much to retain.

This can now be used to lose or soften the hard edges of the paint already applied. Notice how the brush does not enter the painted area.

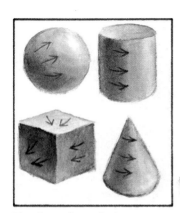

This lost-edge technique opens up the possibility of representing volumes – do experiment.

By adding only a little water, dry paint can be scumbled (or scuffed) across the surface to create texture.

Different brands of paper give different results which can be exploited when scumbling.

By the addition of aquapasto, a thick painting medium, to your mix, lighter scumbles can be achieved.

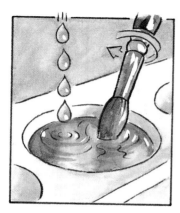

By adding more water, a thinner, more fluid mix is achieved which requires more care to scumble.

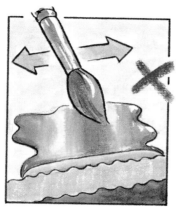

If applied directly to the surface, it will run into the textures and give an even wash.

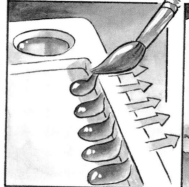

So you must remove excess liquid on the edge of your palette or on a tissue. Move brush head along palette to avoid re-absorbing the paint.

This dry brush can now produce the light scumbles required.

Parts of the scumble can be lost with a damp brush.

Experiment dragging paint across the paper surface with a half-filled brush. Vary the pressure to create irregular brush marks.

Try losing some of these edges and generally use your imagination to exploit the results.

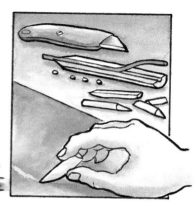

Chop up a white candle and rub across the paper surface. Vary the pressure to apply different amounts of wax.

Wax resists colour laid over it and echoes the texture of the paper.

In order to see where and how much wax you have applied before laying on the colour, look across the surface against the light.

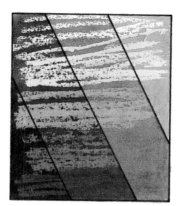

Wax can be used at any stage of the painting. Being transparent its apparent colour will be that of the underlying wash.

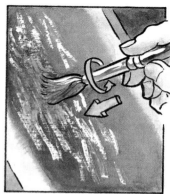

Although wax cannot easily be removed, rubbing paint into a waxed area does achieve heavier coverage and can partially disguise its presence.

Finishing Off

Any over-painting should be applied swiftly and smoothly. Too much dabbing will lift the undercolour and create an unpleasant mix.

Constant overworking can cause the paper surface to disintegrate, resulting in a stained, damaged area.

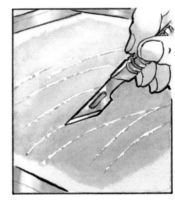

Final highlights can be achieved by scratching or scraping the surface with a scalpel or other sharp point.

These scratches, however, damage the paper surface and cannot be repainted as the affected areas will absorb paint like blotting paper.

Generally, apply liquid to the dry areas using the side of the brush to achieve a thin even layer of colour.

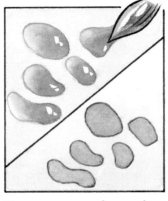

However, you can drop pools of colour onto the surface which dry slowly with dark edges, giving a jewel-like quality.

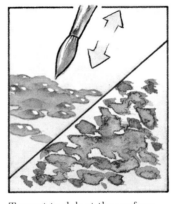

Try not to dab at the surface because this creates an uneven paint layer and the resultant pools form unwanted textures. This is a common problem for beginners.

Do step back periodically from your painting to judge the overall effect; you may be surprised.

At home, look at your painting in a mirror. Faults can be more easily seen from this unfamiliar viewpoint.

Two L-shaped pieces of card can be used to frame your work and help you to judge when the painting is finished.

When it's completely dry, cut the painting from the board with a sharp knife.

Remove it carefully, you don't want to risk tearing the paper at this stage.

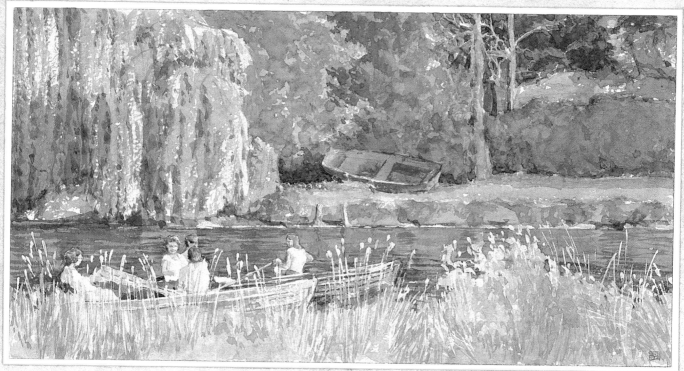

Sharp edges dominate in this demonstration of the wet-on-dry technique. Each brushmark is delineated and therefore the painting must be attacked with enthusiasm and gusto in order not to overlabour it. Remember accuracy is less important than fluidity. Notice how the sharp edges create focus throughout the entire composition.

The figures and grasses were protected with masking fluid so that the painting of the water could be approached freely and energetically. The unusually pale foreground is a reversal of what you would normally expect. However, it creates a contrast to the dark water and reduces the importance of the grass, allowing us to see the figures.

Here all the techniques were combined: wet on wet was used initially with masking fluid resists, while a final layer of wet on dry completed the composition. Compare this with the other two examples and consider the difference made by the contrast between soft and sharp edges.

A wet-on-dry still life. The sharp edges have been lost to give depth and volume. Once again, a preponderance of detail is achieved with this sharp-edged technique.

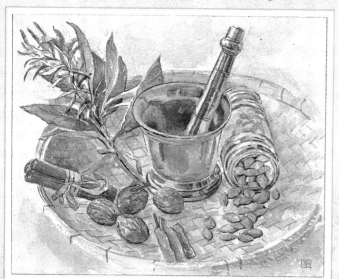

Watercolour Painting: At Home

soon as I realized the cause I moved my easel to capture more light. Fortunately it was in time to rescue the piece. I continued by adding texture to the hat with brown scumbles and strengthened the colour of the green ribbon. I lifted colour from the edge of the fabric against the wall and continued down into the folds to soften their forms.

(*Below right*) My next task was to work on the lace edge of the fabric. If you look at the photograph again you can see that tonally it appears much darker than the highlights of the hat, but if I'd made it any darker it wouldn't have looked white. Yet it needed some sharp accents to make it work against the other areas of the painting which were very strong. After much thought I plumped for an unusual approach at this stage of a painting. I drew in the fine patterned detail of the lace with masking fluid. Once this was dry I overlaid the area with darker colour. When this was dry I lifted off the mask and was so pleased with the result that I didn't work on it any more.

(*Opposite page*) Using a flat nylon brush, I simply blocked in the straw patterning of the hat and used the same colour to give definition to parts of the crown and edges of the brim. I lifted some colour from the ribbon on the right where it trailed across the fabric as this now seemed too dominant and a wash of yellow green was laid over the ribbon as a whole to distinguish it from the background. Lift off was also used to soften the vase so it formed a contrast to the sharpness of the hat. The flowers on the hat provided an important colour accent against all the cool colours in the lower half of the picture and I took care not to overwork the colour.

(*Below left*) It was at this crucial stage that it became so overcast that I realized I no longer had enough natural light to continue. Sometimes this happens so gradually that you do not notice until you have ruined your painting. I had began to despair as the painting seemed so dismal, but as

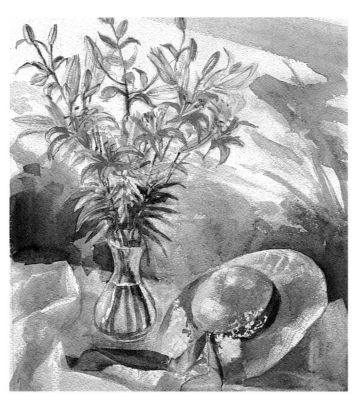

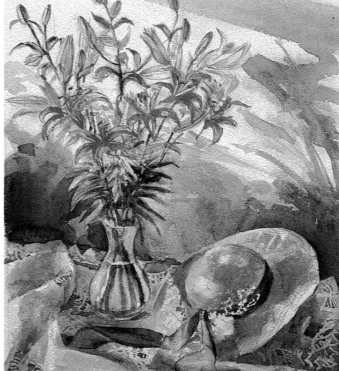

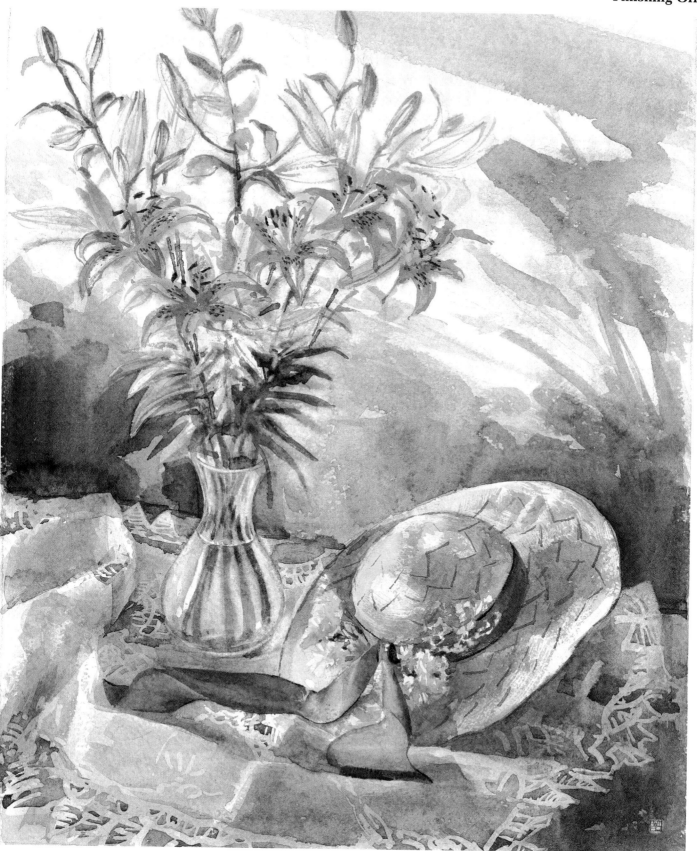

Watercolour Painting: Out and About

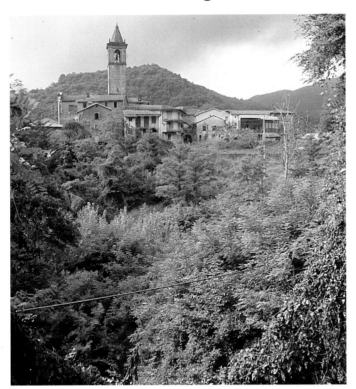

(*Below left*) The final stage of the wet-on-wet application was completed by washing gentle colours across the buildings to give softness and form. The paint application from this point onwards became wet on dry. Bright orange was added to the roofs to provide a strong complementary contrast to the blue of the sky.

(*Below right*) I applied some purple scumbles to the hill behind the building so it would contrast more vividly with the roof tops. Details were added to windows, doors, the church bells and textures to the walls. Where necessary, colour was lifted off, for example, under the arched doorway in the centre of the picture, across the roofs, which had become too harsh, and around the windows to clarify their shape.

(*Opposite page*) By this time the sun had moved around and the shadow forms were resembling those I'd first spied days before. The last touch to the buildings was a gentle red to the roofs to soften the orange. The trees in the valley were now brought into focus using mid- and dark-tone greens and by indicating their branch and trunk structures between the leaf masses. A small purple wall was taken across the hill, appearing and disappearing behind the trees. The trees on the bottom left were not given any wet-on-dry treatment so they created a soft contrast to the harder textures around them. The tree masses in the valley break into three main areas, each with a hard edge against the soft dark areas of its neighbour. This was achieved by wetting up to these edges with a hake. The paint which was then used to render the hard edges, softened and blended into the wet surface next to it. Finally, the vines on either side were given focus with hard-edged highlights. Those on the left were lighter to give the impression of light falling on them from the right.

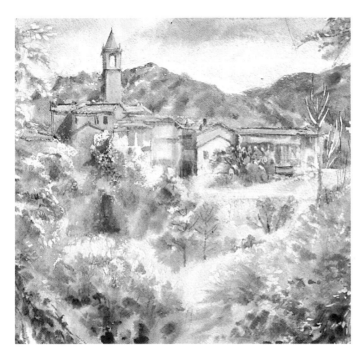

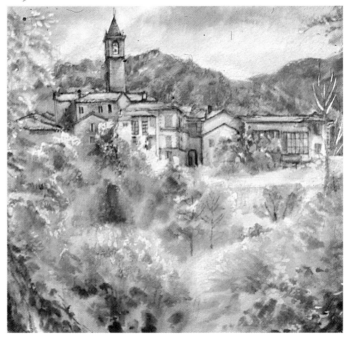

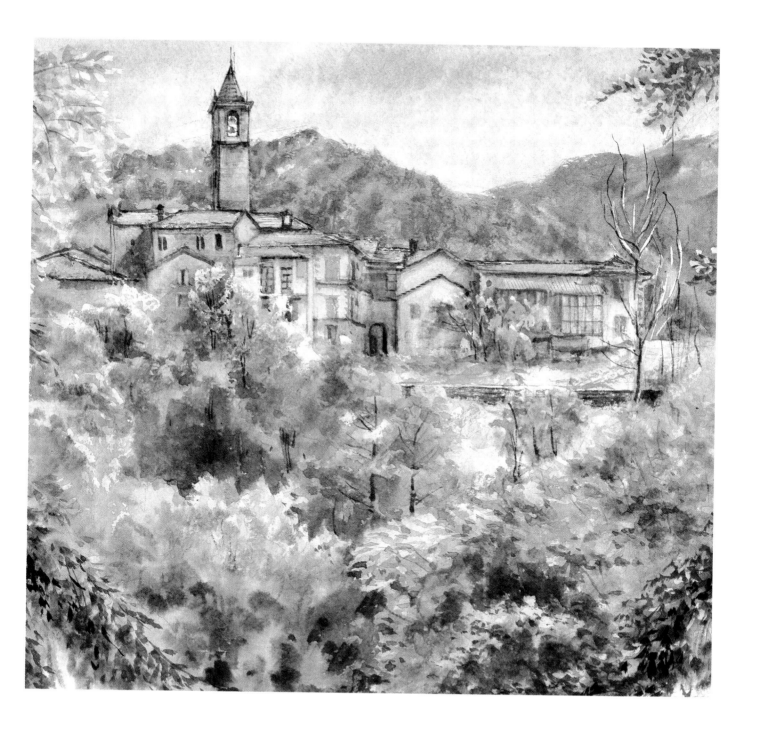

Watercolour Painting: Tricks of the Trade

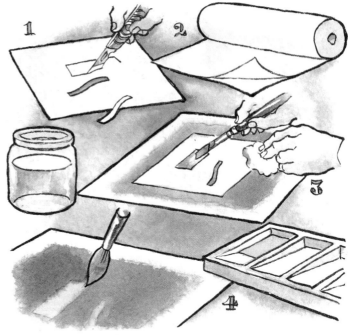

Here, the colour was laid as heavily as possible so the detail could be lifted off using masks. These can be cut from either stiff paper (1) or low tack adhesive film (2). Place the mask over the dry colour and remove the paint with a flat nylon brush and a tissue (3). Then drop some colour into the lightened areas (4). Some final sharp high-lights were scratched off with a scalpel. Test your paper's lift-off qualities before you embark on a large project. Well-sized papers lift off well, whereas others absorb the colour into their fibres and are impossible to use for this technique.

Here, gentle pencil lines (1) control the placement of heav-ily painted masses (2). These are then lifted off to give tex-ture and volume (3). Masks can be employed for the lift off as above or it can be done freehand. Colour was applied to the lifted areas and the whole composition tightened up by the addition of Indian ink linework (4). This can be applied with a dip pen, a technical pen, felt tip, rigger or brush pen. The colour must be lightfast.

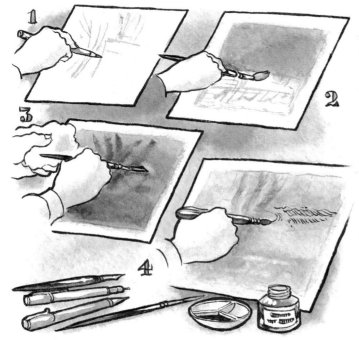

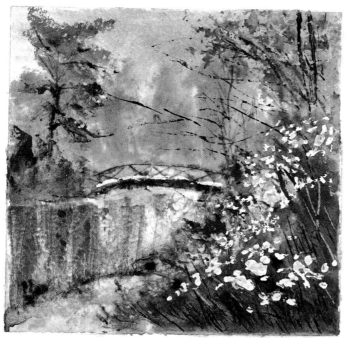

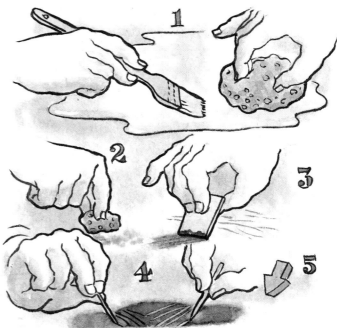

Here, after wetting the surface with a hake or large natural sponge (1), a smaller sponge was used to apply the leaf textures (2). Small pieces of card, cut to size, were used to create the branches, tree trunks and water textures (3). These were then pulled together with linework applied using a small stick (4). Scratching and scraping off paint with the stick (5) created linear textures for branches and undergrowth. Masking fluid can also be applied using sticks and sponges and was used here to mask the yellow flower heads.

Wet on wet gives soft-edged marks, but where wet on wet is applied to a restricted area their edges dry hard. Here, the shape of the flowers and stems were wetted (1) and fluid colour dropped in (2). This spread across the wet surface, producing the distinctive mark shown. Large areas of paper painted with light colour (3), had stiffer paint dropped in while still wet (4), resulting in internal soft edges with hard outer edges.

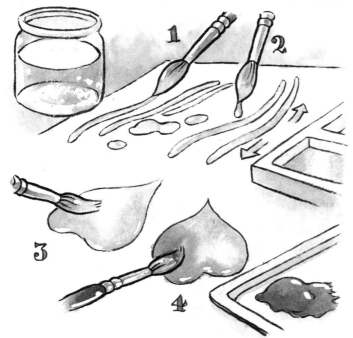

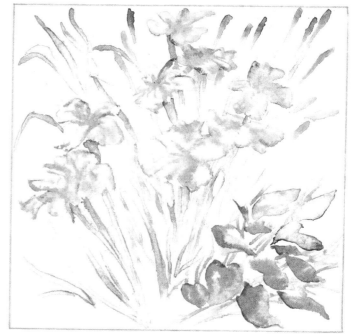

Watercolour Painting: Common Problems

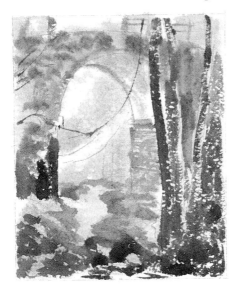

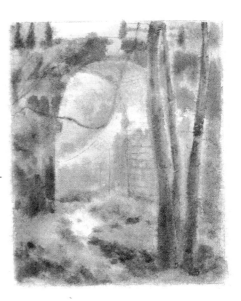

PROBLEM When painting wet on wet, the surface dries and hard edges occur such as those around the tree trunks. Although these marks have a certain quality, they are not required at this stage.

SOLUTION As soon as hard edges begin to form, stop and allow the surface to dry thoroughly. Then rewet and continue painting. Wet-on-dry marks can be added after this stage in a controlled manner.

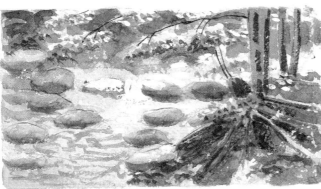

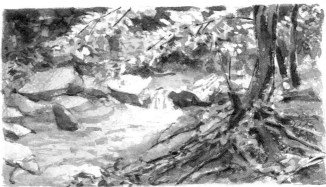

PROBLEM We all have a tendency to apply paint using regular brushmarks which results in a regularly patterned surface. In this case all the leaves, boulders, etc. are a similar size and shape and their textures repetitive.

SOLUTION Always be on the alert. It's very easy for regular patterns to emerge. Make sure that the negative shapes around your forms are irregular, thereby more natural.

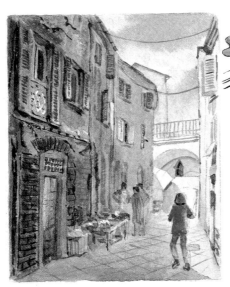

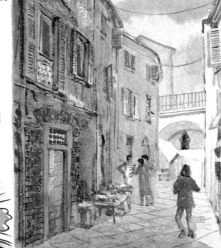

PROBLEM Several layers of mixed colour have been built up and the overall effect looks grey. This often occurs in shadow areas where dark tones are required.

SOLUTION The final layer of colour should be as clean a mix as possible to bring back the vibrancy of the colour. It should certainly not be dulled with complementaries. The matching, therefore, takes place on the painting surface itself. The palettes show the relative colour mixes for the final layer of the brickwork around the door.

PROBLEM Here, while trying to paint the background sky around the complex tree silhouette, the edges dried creating unwanted textures.

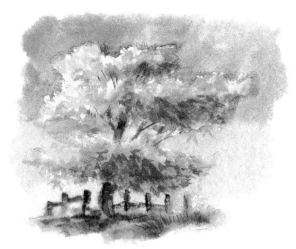

SOLUTION Rewet area with a hake before applying background colour. Wetting up to the tree trunk produced a hard edge (*see top left*), while wetting over it produces a soft one (*see bottom left*).

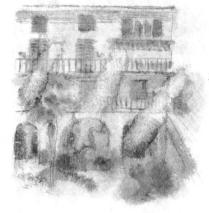

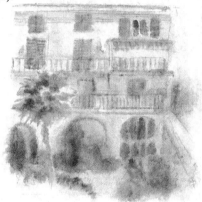

PROBLEM When painting wet on wet, the natural tendency is to lie your board flat. However, pools of water collect, the paint runs and, as a result, the surface dries unevenly.

SOLUTION Stand the board upright so any excess water runs off before the paint is applied. If you find this difficult to cope with at first, start at a gentle angle and slowly increase the tilt. You can adjust most easels, so do experiment.

PROBLEM The depth of tone in the colours looked perfect while the surface was wet, but on drying the colours lightened and became pallid.

SOLUTION With experience you will learn how much the colours lighten. Eventually, with confidence, you will begin to use stronger colours. Remember, you can always lift off colour if it is too dark.

Using Pastels

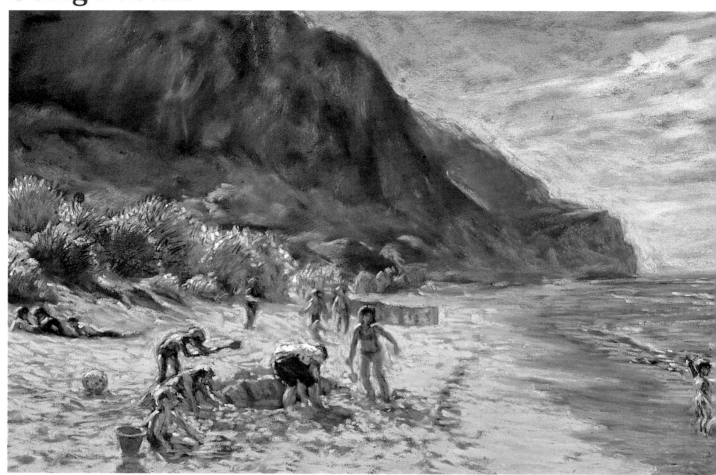

There are many different forms of dry or drawing media such as charcoal, pencil or conté. The closest in nature to paint is the soft chalk pastel and work in this medium is sometimes referred to as pastel painting.

The pigment used in pastels is exactly the same as that used in paint but, because it contains no base medium, only a small amount of binder to keep it in stick form, it is much purer. This gives pastels an intensity of colour that is unsurpassed by any other medium. Next time you have the chance, look at a set of new pastels lying in their box and see how they seem to glow the colours are so intense; this is because you are looking at almost pure pigment.

For beginners they are an ideal medium to use for they possess many of the painterly qualities of fluid paints but are far easier to apply. You don't need any brushes or specialist equipment as the pastel itself is your painting instrument. This also makes them ideal for outdoor use.

When you first get your pastels, experiment with making marks of various kinds so you become familiar with the effects that can be achieved. Try mixing the colours directly on the paper, smear them together with your fingers and note how this blending affects the texture of the pastel. Be careful though, soft pastels are very powdery and the coloured dust will coat everything, possibly damaging furniture. The ideal is to have your own work area so you don't feel inhibited, but failing this you will just have to take extra care when using the medium heavily. Working outdoors, however, does not present you with such problems. You can blow, or tap, the surface to get rid of the excess pastel dust.

You don't, however, have to use the pastels dry. It is possible to add water to the pastel using a wet brush or the steam from a kettle. This transforms the pastel into a thick paste-like liquid. Or, if you apply a thin layer of pastel to your surface and wet this with a brush, the result is not unlike a watercolour wash.

As you become more familiar with the pastels' qualities you may notice their affinity with oils. Both media are opaque and can cover completely or partially, the colours over which they are laid. This, of course, means they are both very forgiving media; mistakes being easily erased by the laying down of a subsequent layer or layers. In both media you are encouraged to suggest detail rather than paint it. Beginners often feel more comfortable, however,

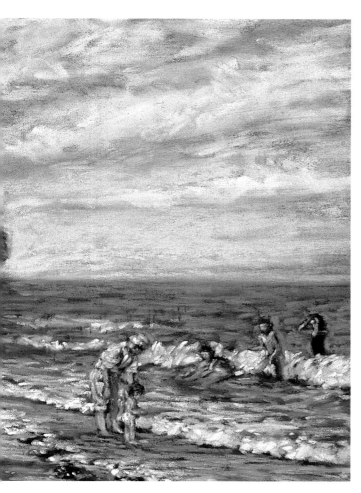

light and shadow. The depth of tonal contrasts available when using pastels, from the deep dark tones of pigments worked onto a coloured ground through to the bright, intense tones of the white highlights, makes the rendering of these qualities relatively easy to realize.

Still lifes too, which demand a medium flexible enough to express a multitude of textural qualities from the sharp, reflective surfaces of vases or pots to the soft surfaces of fabrics and flowers, fall easily within the scope of pastels.

When using pastels to portray flowers it can either be applied as a thin wash over a coloured line drawing on watercolour paper; or by working the pastels directly onto a coloured ground, preferably one that is complementary to the dominant colour being used. The first method is suitable if you wish to portray intricate detail the second if you wish to take a more dramatic and suggestive approach.

One limitation of pastels, which can be frustrating for the beginner, is that you cannot mix colours as easily as you can with paint. You may be trying to paint a flower, for example, which is of a shade not available in your set of pastels. You have to accept that you won't be able to recreate the colour exactly and use the nearest tone available. By concentrating on the flower's tonal range and emphasizing the soft or hard qualities of the petals' surfaces, anyone looking at your work will focus on these aspects and probably won't even notice the change in colour.

A similar problem arises if you do not have dark enough pastels in your range with which to achieve dark accents. The darkest colours in pastel are produced from pure pigment and, as a result, can be very intense. Although pastels can be mixed on the surface by rubbing the colours together, beginners may find it off-putting to mix such intense colours when trying to achieve dark dull shadow areas. The easy solution is to mix your media. Watercolour, gouache or acrylic paint can be applied in dark washes to create shadows and once dry will yield a series of dark silhouettes on which to evolve lighter tones with the pastel. If you do this, you may need to stretch your paper before you begin.

Your finished pastel won't be safe from damage, no matter how much fixative is applied, until it is mounted behind glass. The mount is necessary to prevent it touching the glass. A word of caution however, if you leave your work with the framers they are more than likely to fix it for storage reasons. In doing this the work will lose its highlights. To avoid this, take the work with you to select your mount and frame; having done so, take it home again. Ask your framer to make a demountable back for the frame and insert the pastel yourself.

Don't let these minor difficulties put you off. Pastel is an extremely thrilling and dramatic medium in which to work and will give you many hours of pleasure and I hope you find the following section inspiring.

with the dry medium of pastel because it is easier to control, more immediate and involves less equipment than using oils.

Working in pastels also means you can work on coloured surfaces which enables you to judge the true intensity of the colours you are applying. A white surface is not an ideal ground for judging tonal values and it can also be very intimidating. Fortunately the opaque quality of the pastels means it does not require the luminosity of white paper beneath it.

You will find that once a few layers of pastel have been built up, it achieves a painterly feel you would expect from fluid paints and its finish can be almost indistinguishable from a painting. Its versatility therefore makes it a very appealing medium for those who wish to deal with a wide range of subject matters.

For portrait painting, the luminosity of the pigments and their softness when blended make it an ideal medium for portraying both the tones and texture of flesh. It can also create the hard and soft contrasts required to suggest fabrics, hair and eyes.

For landscapes you need to create feelings of distance,

Using Pastels: Materials and Preparation

PASTELS Most people's introduction to pastels is when they buy, or are given, a box of pre-selected colours. Once they try and put them to use they unfortunately find the colour and tonal range too limiting and the pastels are stored away, never to be used again.

My initial advice then is not to buy a box, but to buy individual pastels. Most boxes contain a selection of colours, but the majority are in the mid-tonal range. To create light and form you need dark and light tones as well. It is therefore, much more sensible to limit the number of colours (hues) that you use and concentrate on increasing the number of tints, giving yourself a light to dark range. (See page 125 for a full explanation of hues and tints.)

VARIETY AND QUALITY This section deals with chalk pastels which are composed of pigment (the colour), chalk or clay (to produce tints of the colour) and a wet binding agent (to form the mixture into sticks). The amount or type of binding agent, determines how hard or soft the pastel stick is. This section deals exclusively with the top range of Artists' quality pastels, which are the softest and therefore contain the least binding agent.

You can easily determine whether your pastels fall into this category by a simple test. Run one across the palm of your hand. If the pastel easily covers your flesh, then the pastel is of the soft Artists' quality variety. It is this softness that we are going to exploit when building up layers of colour.

If the pastel does not mark your hand it is a harder variety, even if the box in which it came states the contents are soft pastels. This type of pastel can be used for the initial layers in the techniques I am about to describe, but should not be used over the soft Artists' pastels. It will be extremely difficult to make them adhere to the latter and the pressure involved will tend to lift the soft pastel from the surface.

Pastels also come in a variety of shapes and sizes. The Artists' quality soft pastels are generally round. The largest ones, which I prefer to work with, are ideal for covering large areas quickly. Some are covered in paper, to protect the pastel from damage or from soiling other pastels. These sleeves also prevent your hands getting so dirty. However, they can make it difficult to spot a damaged or broken pastel – a nuisance when choosing which to buy and if you are intending to use the side of the pastel for covering large areas. To avoid buying a damaged pastel, hold one end and pull gently on the other to make sure it's all in one piece.

HUES AND TINTS The various tints of any hue (colour) are achieved by mixing white chalk or clay with the pigment. The amount of this added material affects the lightfast-

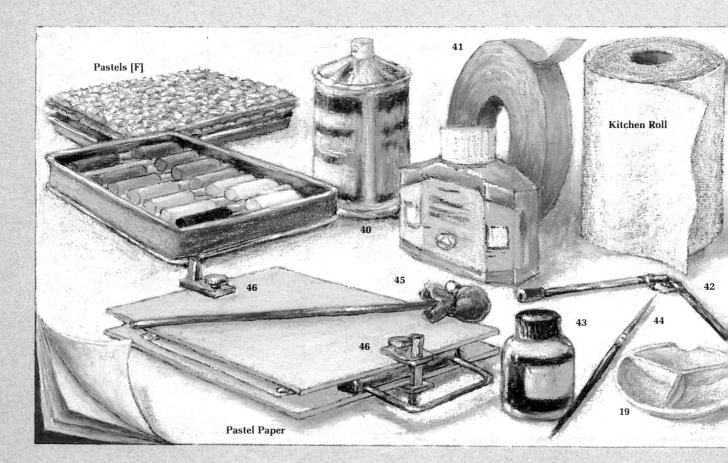

Pastels [F]

41

Kitchen Roll

40

45

46

46

42

43

44

19

Pastel Paper

ness of the resulting colour. It is therefore sensible to use pastels containing the best pigment available to ensure they are as lightfast as possible. Most manufacturers show the degree of lightfastness on their colour charts. The Artists' quality pastels will give you the most lasting results.

Colour names can be a little confusing when buying pastels. There are some standards, but many mixes carry the manufacturer's own colour name. As a result, similar colours can vary in name from one brand to another, so ignore the colour names and consider the range of colours you already possess and their position on the colour wheel. Take the colour red, for example, ask yourself whether you need a purple red or an orange red, and buy accordingly.

Remember that in this medium, colours are not as easily mixed as they are in paint and so you will need a greater range to achieve a full colour palette. You will probably need to include some secondary colours and a few browns. Most importantly though, you will, for each colour, need its range of tints.

You can see that it would be easy to end up buying a vast range of colours. This isn't necessary and could become very expensive, especially if you then found they were not to your liking. You can achieve a great deal with a limited palette so read through the artstrips at the beginning of this section before buying your colours.

The darkest tones available vary according to the brand. Some achieve the darkest tones using pure pigment alone, whilst others add black. Those made from pure pigment are wonderfully rich and can always be dulled down by mixing with a complementary colour on the surface. For example, blending a dark ultramarine with a burnt umber produces a very dark grey which is almost black.

Pastels that have been darkened by the addition of black will have lost some of their intensity but can nevertheless still be used in shadow areas as you rarely need a very dark colour to be very intense. Adding black to a colour also helps to keep down the price of the pastel, as black is cheaper than most of the pure colour pigments.

STORAGE AND TRANSPORTATION Pastels are extremely fragile and easily transfer their colour onto each other. This poses a problem when you wish to work in the field. My advice is to take as few pastels with you as possible. In practice you seldom use all your colours and you'll learn from experience which you use most.

I have heard of artists who transport their pastels in dry rice and retrieve them by running the rice through a sieve. The rice cleans them as well as protects them from

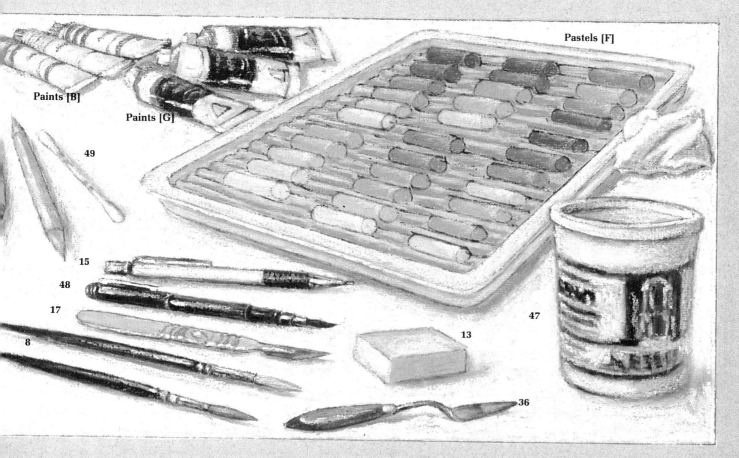

Paints [B]

Paints [G]

Pastels [F]

49

15

48

17

8

13

47

36

Materials and Preparation

breakage. I personally line a flat tin with corrugated card, and lay the pastels in the grooves of the card. I then lay a piece of bubble wrap, or a thin layer of foam, over the top to protect them from the tin lid. I find this holds them in place quite happily.

They still pick up some colour from each other, but in all honesty this is inevitable. It is always just as well to test the colour before use anyway as the outside appearance can eventually hide quite a different tint. If you have a selected place in the tin for specific colours and tints, this problem is somewhat reduced by always placing the stick back in the same slot. I find, however, that when I'm absorbed in a piece of work, I'm not that organized and end up with half a dozen pastels in my hand, all discolouring one another.

In the studio, I use a large square plant tray, again lined with corrugated card, to hold all my pastels. This is covered when not in use to protect the pastels from dust and marauding cats!

STUBS Pastels can be blended using your fingers, a piece of cloth or a compressed paper stub. Some people find the friction required and the pigments in the pastel irritate their skin when using their finger. If this is the case then use a stub (see page 15 for details on making your own) or buy one made from compressed paper. This is much tougher than any you can make and is useful for forcing the pastels into the paper when underpainting.

PAPER Pastels, because of their powdery nature, need specially textured surfaces to which they can cling. A heavily textured surface can take a heavier application of pastel and a greater number of layers.

Not and Rough Watercolour Paper (see page 18), can be used as well as specialist pastel papers and pastel boards. Some artists work on sandpaper, but while this gives a tremendous tooth, it's not acid free and the backing paper will deteriorate.

Of the specialist pastel papers, there are two types: a moulded grained surface which I prefer (see page 127), or a velour or flocked surface. Try out the various types to find out which you prefer. These pastel papers and boards are also available in a vast range of colours, most of which are lightfast. You can use sugar paper, but the surface isn't really adequate to hold successive layers of colour, and any paper left showing will fade as it isn't lightfast.

One way of creating some really interesting textured surfaces is to make your own. Washed sand mixed with acrylic medium and painted onto paper or board creates a good tooth as does acrylic texture paste. This can be dragged or stippled across your surface with a bristle brush. Acrylic paint itself, when built up directly from the tube will create textures to which the pastel will fix. Experiment with these and perhaps think of some other substances to mix with acrylic medium, to create different textures for the pastel to exploit.

If you intend to apply any paint with the pastels you will probably need to stretch your paper. The thinner pastel papers only require a quick dip in a bath of water to absorb enough before fixing to your drawing board.

FIXATIVE Fixative is useful for protecting your work as the resin it contains helps bind the pigment to the surface. It can also be used to stabilize a piece of work if subsequent layers are to be applied. It is available in either liquid or aerosol form; both are equally good. The fixing process does, however, make the pastels more transparent resulting in the lighter tones becoming duller as the dark underpainting, or ground, shows through. For this reason it is common to fix early layers of work but to leave the top highlight layer in its natural form.

Always remember to apply the fixative in a well ventilated room, or outside, as the fumes are extremely harmful. It is better to apply three light coats of fixative, than one heavy one. You should not be able to see a colour change as the fix hits the surface.

ON COMPLETION Once your work is complete you must protect it, as the slightest knock can damage it. If I'm in the studio, I pin it high up on the wall, where it is well out of harms way. If I'm outside I pin my work to one of two pieces of plywood which I then carry home in a canvas carrier (see previous page). The latter comprises of two metal clips which are normally used for transporting oil canvases. In this instance, however, they carry two plywood boards on which you can pin your pastels. Make sure when you assemble the package that your work is on the inside.

A range of pastel tints for each colour of·your palette is essential to create light and form.

True Artists' soft pastels for 'pastel painting' are so soft that if you run one gently across your palm it will leave a mark.

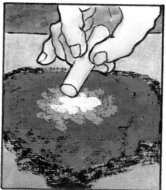

Pastels as soft as this can be more easily layered on top of one another . . .

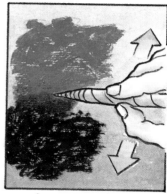

. . . and are very easily blended into one another on the surface using a finger or stub.

The surface on which you work must have a tooth to hold the pastel as the above magnified section and cross section show.

A drawing or watercolour fixative in aerosol or liquid form is suitable to use on pastels.

Take care that large droplets don't fall on the surface, more likely if you are using a liquid fixative, as they can damage the pastel surface.

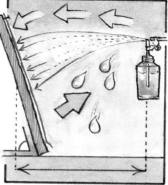

Fix pastel to a tilted board for fixing. Keep a good distance away from the work, at least 50cm (18in) away, before spraying. This ensures the spray hits the surface gently.

Before using fixative for the first time on a finished painting, mask a small portion of an experimental piece with paper. Weight or hold it down.

On removal it will give you an idea of the colour and tonal changes that occur with fixing.

If you apply the fix in the pattern shown it will be heaviest on the turn around and may even form pools.

Instead, go right across (or up and down). Take care not to damage any surfaces behind the board. Three fine layers are better than one heavy layer.

Using Pastels: Starting Off

Draw out composition lightly on pastel paper. Cover the drawing board with paper if the wood texture shows through when applying the pastel.

Apply some Indian ink with a fine brush (rigger) to complete the drawing with a descriptive line, i.e. one that varies in quality and thickness.

Brush pens (pens with a brush head in place of a nib) are excellent for linework. They have a waterproof ink cartridge which means you don't have to keep dipping it in ink.

Rub a large round, oil painter's bristle brush over the surface of a pastel to pick up some loose pigment.

Transfer this pigment to your drawing and work into the surface.

A small brush gives more detailed coverage, but the colour runs out quickly. Larger brushes cover greater areas and hold more colour.

Lift off highlights with a putty rubber. These highlights will be the colour of the paper (ground).

Add some final white highlights directly with a pastel stick to contrast with the ground colour.

Alternatively, apply colour directly to the line drawing using your pastels. This allows a much heavier application of colour.

Add water to the surface using a large soft round brush, spreading the pastels up to the edges of the outline.

Applying water thins out the pastel and allows the linework to show through.

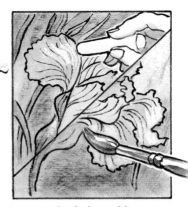

Leave to dry before adding a lighter colour using this same technique.

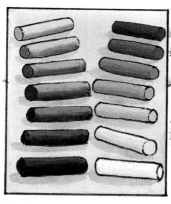

Working with a limited palette you need only use two colours as long as you have several tints for each, plus black and white.

Using your thumbnail, score around your pastel about 12mm (½in) from the end and snap off.

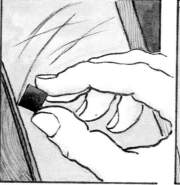

Use the edge of this small piece to produce the linework for your initial drawing.

Using black or dark brown, transfer the loose grid of your thumbnail to your work in the usual way (see page 12).

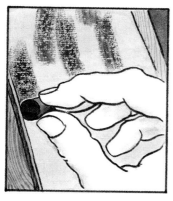

Now, using the side or flat end of a pastel piece, block in the dark masses using browns and blues. Note how the texture of your paper shows through.

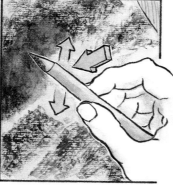

Use a compressed paper stub to blend the colours and force them into the paper's texture. The coverage is now more solid and stable.

A cloth, or even your finger, can now be used for the same purpose, but it is less precise.

Any linework or drawing lost can be re-applied. Blend with the line rather than across it otherwise it can disappear.

The surface can be fixed at this stage to make the next layer easier to apply.

Work right through the picture, successively blocking in lighter blues and browns.

Remember, use the sharp edge of the pastel for line and detail, and the side for broad marks – the pastel equivalent of using small and large brushes in painting.

Blend more gently as the layers of pastel build up. Use softer rolled stubs of paper. Too much pressure will mix top layers with underlying ones.

Starting Off

Only fix at this stage if the surface becomes too powdery and impossible to rework. But beware, the pastel becomes more transparent and you will lose highlights.

Rework with final layers of light blues and browns.

Work from the top of the picture down (i.e. from the background to the foreground). In this way you will overlap forms and achieve a sense of depth.

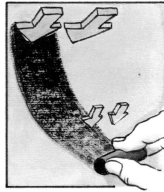

Note how pressure variations increase or decrease coverage.

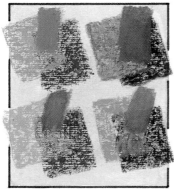

Blue can be laid over and mixed with browns and vice versa to produce greys.

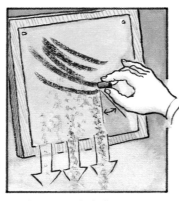

Working upright helps to prevent accidental smearing with your hand and any excess pastel easily falls away.

Every so often, tap board or blow gently across your work to remove loose, fragile pastel.

Pure white highlights and dark accents in black are now applied in selected areas to complete the tonal contrast. They are seldom blended.

Extra pressure is needed to apply such highlights. Use the whole stick, with its clean sharp edges, and increase the angle of application to accommodate the extra pressure.

Note how white highlights on light blue appear blue and those on light brown appear brown. Against a dark colour, however, such highlights just look white as there is too much contrast.

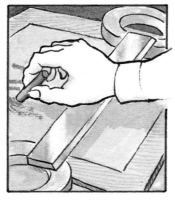

If you prefer to work flat you can keep your hand from smudging the surface by using a ruler as a prop.

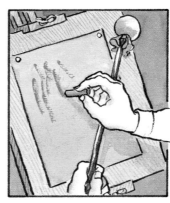

If you are working upright you can use an oil painter's mahl stick for the same purpose.

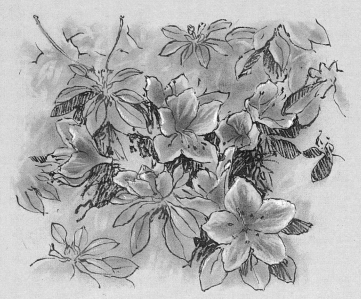

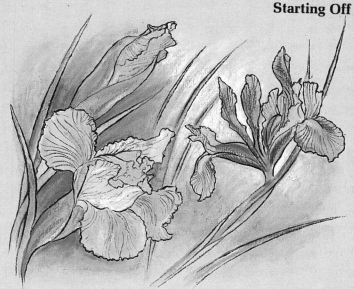

Here the pastel was applied dry using a bristle brush (*see page 56*). The effect created of soft colour and hard line-work was not unlike that of a line-and-wash watercolour. The application is obviously much stiffer than watercolour as the pastel is dry and, because it is applied thinly, the result is modified to a great extent by the ground colour of the paper. Note how the white highlights create the perfect foil for the intensely dark accents of the linework.

The pastel layer here was applied much more thickly and then diluted with water using a soft round sable brush. You can apply the pastel far more accurately when it's wet as it becomes paint-like. Once dry, however, it returns to its powdery pastel form. The advantage of only adding water is that the pigment retains its intensity. You can mix it with a gum medium but it will become duller although more subtle. This will have the effect of turning the pastel into a true watercolour paint and could be useful when using watercolour if you require a small area of bright colour.

A more traditional approach was taken here by applying the pastels directly to the paper but using a limited palette of blues and browns. Although it may not be as obvious as in the other examples, the ground colour here is still play-ing an important role as a third colour behind the applied pastel colours. The maximum contrast of black accents against white highlights is restricted to the area around the figures and, even though the figures are not over detailed, gives a focal point to the whole composition.

I have produced many pieces using this restricted palette, and not only winter subjects. It is interesting to note how little colour is actually needed in a painting and how much colour our brain imagines, providing we have a full tonal range.

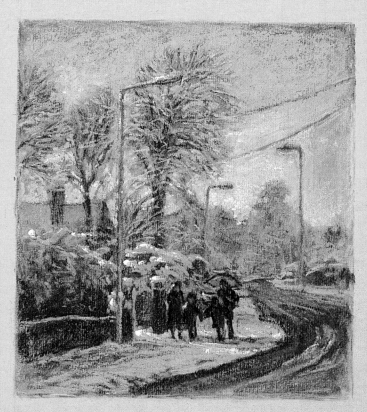

Using Pastels: At Home

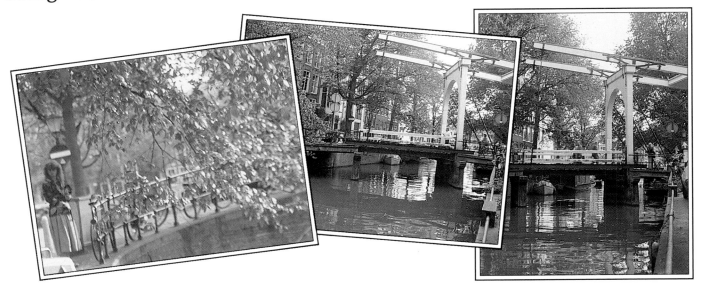

I recently made a two-day trip to Amsterdam with the express purpose of visiting its many wonderful museums and art galleries. I was soon itching to take up my brushes to record the many captivating views. But I only had two days and, with such a crammed itinerary, I was frustrated in my intentions. Fortunately, however, I never travel anywhere without my sketchbook and camera and on this occasion they came into their own. I record different information with each. I use the camera to capture colour, light and atmosphere while I use my sketches to sort out ideas on the spot and which together with my thumbnails help me decide what to photograph. Some of the jottings from my sketchbook are shown on the opposite page. As you can see they don't have to be finished drawings, so long as they capture the essence of the view and can be interpreted later when you have time to paint the scene. Even if you never use them for a painting, they make a wonderful keepsake, far better than any photograph.

With this particular view I was thankful that I had completed my thumbnails on the spot. At home, looking through my developed slides, this view could have been lost in the many other shots I had taken. On the scale of a slide or even a photograph, the drama, colour and depth is lost; however, my thumbnails were able to remind me of my original vision. Several photographs had been taken to capture all the elements my thumbnails had exposed as being essential.

A little too cramped either side of the bridge

Path and bicycles look like an after thought and the lamp squashed in

Nearly there but the bridge is too dominant

This will do nicely

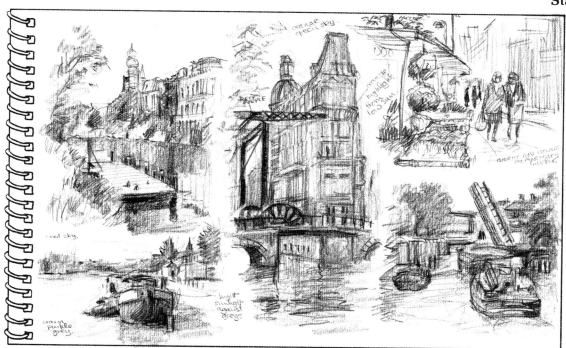

(*Below left*) I used a black pastel to transfer the outline of my thumbnail sketch to the pastel paper. I blocked in some tone with a dark brown so I could judge the balance of the masses on this larger scale. It is very easy, when enlarging to this degree, to transfer the thumbnail proportions inaccurately. So I stood well back from my work to make sure I did so correctly.

(*Below right*) The initial colours were blended into the surface with a compressed paper stub. A series of dark colours, each relating to its tonal area, was blocked in. This divided the picture into distinct areas and gave an even greater insight into the compositional and colour balance of the piece. I blended the colours into the surface to stabilize and mix them with the colours beneath. Where really strong darks were required, the pastel was blended heavily and it covered the ground colour effectively, but in other areas where less blending and consequently less pressure was required, the paper colour would show through. The surface was now heavily fixed.

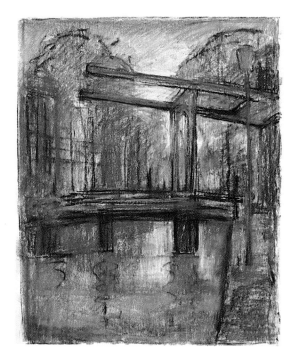

(*Continued on page 68*)

Using Pastels: Out and About

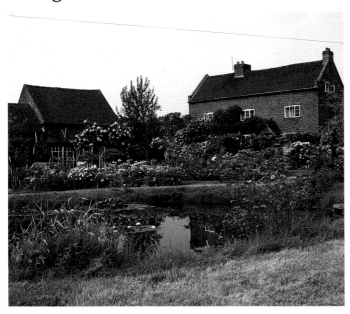

What an idyllic scene; a pond filled with lilies surrounded by a beautiful rose garden. I could paint several pictures from this same spot, each one focusing on a different aspect of the view. Today, in this light, I feel greedy and want to capture the whole scene. There is such an abundance of detail, however, that I will have to simplify the scene with suggested detail if I am to complete the painting in one day. In my mind's eye I have already broken down the view into five layers – the sky, the buildings, the roses, the pool and the foreground. Each is strong and the composition will need careful balancing to avoid it becoming busy and confused with detail.

Note the very strong light coming in from the left of the view and how the buildings on this side are thrown into shadow. This contrasts well against the large sunlit building to the right and the roses catching the light in front of it. As the day progresses and the sun moves this will change so I must remember the tonal qualities I see now. It is always worthwhile spending a few minutes before you begin just looking at your subject so you can evaluate these sorts of relationships.

Encapsulates view, but sky shape is boring and building insignificant

Composition lifted. Better, but too much foreground

I wonder, would it fit a different format?

Or perhaps a squarer rectangle?

The best of all worlds ✓

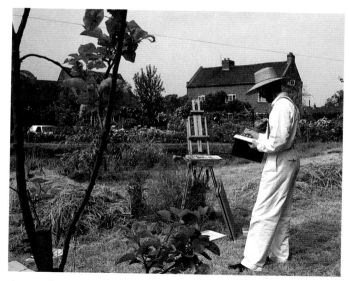

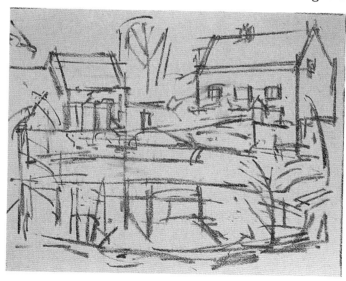

A wonderfully hot, summer's day and what a joy to be painting in a setting like this. The most essential piece of equipment today is on my head. If you stand all day long in hot sun without a large hat you will suffer the consequences. Passers by often giggle and say I remind them of Monet or Degas, but friendly ribbing is better than sunstroke. No sooner is my easel set up than I am scribbling down my thumbnails. I keep them in a sketchbook as, even though they have no value, I like to look back on them.

I used a black pastel to transfer the grid of my thumbnail sketch to the pastel paper. Then, working directly from the view, I added more details with a dark-brown pastel. This meant I could easily identify any changes to the initial concept and at the same time not lose the main structure. The advantage of this becomes more evident in the next step.

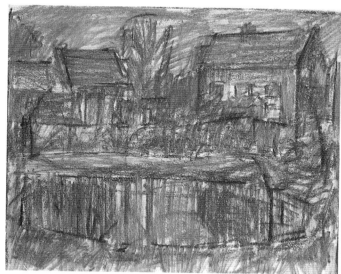

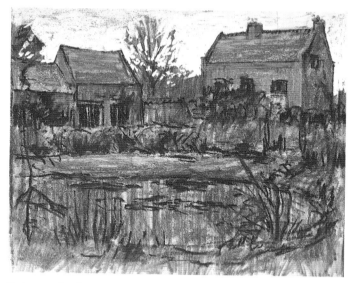

Using the edge of this same brown pastel, I blocked in dark tones across the whole composition. The direction and pressure of the pastel strokes began to mould the forms. I applied a dark ultramarine to the cooler parts of the painting and blended the two colours together with a compressed paper stub to increase their softness and coverage. The pastels were blended in the same direction as the original strokes, retaining the structure of 'moulded' forms. The painting could now be viewed in terms of mass and tone rather than line. At this stage, I reviewed my composition to check if I wanted to make any changes. The pastel was now fixed so further layers could be applied.

I changed a few details and accents by re-drawing with a black pastel. This was then blended into the surface and fixed. Working from the horizon upwards, I created a graduated blue sky, silhouetting the building and trees strongly against it. Rich orange and purple scumbles laid over the buildings created warmth and light. In some places they were so strong against the dark ground that they had to be toned down by applying a dark blue.

(Continued on page 70)

Using Pastels: Techniques

Lay out your pastels in a logical order so they are easy to reach. Try to be organized or your pastels can get very messy.

You could arrange your colours in the same order as that of the colour circle.

I like to keep my blues, browns, and black and white pastels in a separate tin, so they are easy to transport and available for 'limited palette' work.

Drawing: use a 0.5mm automatic pencil to gently transfer your thumbnail sketch to your pastel paper. (*See page 67* for finished painting.)

This linework can be strengthened with a black pastel and solid masses blocked in with a dark colour. I used blue to suggest the coolness of evening shadow.

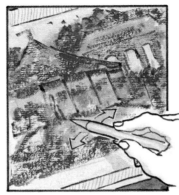

Work the pastel into the surface with a compressed paper stub. Don't cover all of the ground (paper).

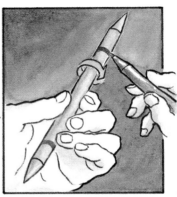

A compressed paper stub is usually double headed. Keep one end for warm colours and the other for cool. Colour code them as a reminder.

The pastel can be fixed now and then regularly throughout the painting. But note how the tones darken as their transparency increases when fixed.

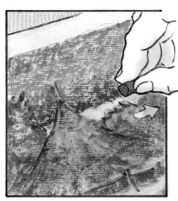

Underpainting: apply mid-toned bands of strong colour, moving from cool to warm, to produce colour gradations. Useful for depicting skies.

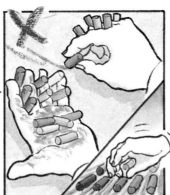

Try not to keep any more than two pastels in your hand at a time. Return them to your box as soon as you have finished with them.

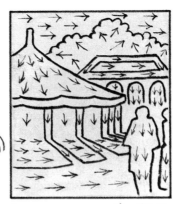

As you move across the picture surface, change direction of marks to model form and structure.

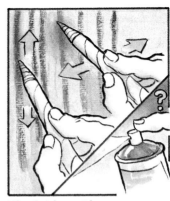

Blend either with, or across, marks to achieve softness using a gently rolled stub. Fix if necessary.

Overpainting: the lightest colours can now be overlaid e.g. pale blue over the sky.

If the overpainting is too powerful or sharp it can be gently blended into the underlying colours . . .

. . . or you can use fixative to reduce highlights allowing the undercolour to shine through . . .

. . . or you can scratch down to a darker layer with a knife using the point for details and the blade edge for wider areas.

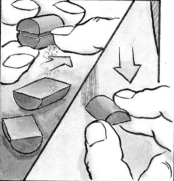

To apply the colour more sparingly rub some colour onto a stub and use this to transfer the pigment to the surface.

For more detailed work, split your pastel piece again.

Using small pieces like this keeps the main body of your pastel clean.

You are not aiming for complete coverage in any layer. Otherwise you will lose texture and the underpainting will have been wasted.

Remember, start with soft dark blended marks, and finish with light directional texture thus creating soft to hard focus as the layers build up.

Tints: areas which appear too close because they are overly dark can be gently overlaid with a light blue. The tint produced recedes in space giving more depth.

Final dark accents can still be applied in black or dark blue as can highlights in pure white. These final touches usually remain unfixed.

Your final piece of work can be temporarily protected by a paper flap, but it will need window mounting and framing under glass as soon as possible.

Techniques

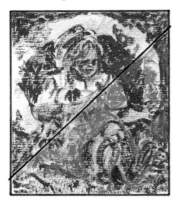

Underpainting (method A): make the initial drawing using a mid-toned warm brown overlaid with a cool mid-toned blue (*see opposite page*).

Blend the colours. The resulting greys create a balance between warm and cool areas across the picture surface.

Overpainting can continue with this warm/cool layering, e.g. complete first layer of dress in brown, followed by mid blue, pink and light blue.

Or you can work through lighter tones of the same colour family, e.g. for the flesh start with brown, then mid orange, light orange and pink.

The direction in which you blend the colour is as important as the direction in which it was applied to create structure.

The contrast between soft, blended edges (A) and hard edges (B) gives definition to the form.

The order in which you cover the surface needs to be planned as the overlapping of forms creates a feeling of depth.

Extra pressure is required to achieve the final white highlights. Try tapping the surface with the pastel, e.g. this technique could be used to portray spots on the dress.

Underpainting (method B): use bright light-toned complementaries, e.g. orange under a blue sky, red under green trees, etc. Blend into the surface (*see opposite page*).

Complete any re-drawing with a mid-toned turquoise blue. Blend in direction of the line to stabilize it.

When overpainting, note how a graduated mark can be achieved by applying uneven pressure across the pastel piece.

Light tones of your dark colours can be achieved by covering the surface with white pastel and then adding colour lightly over it.

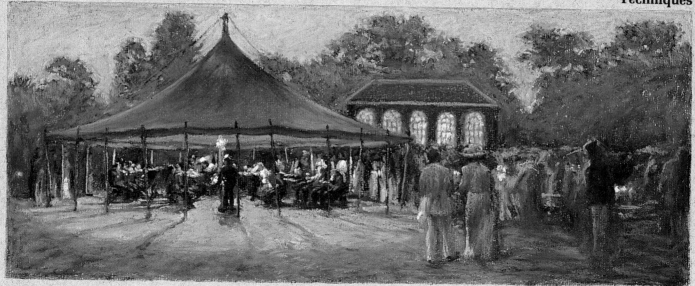

Black was used as an undercolour in this study of light as it gave the extreme range of contrasts necessary. The tonal values between the darkest shadows and the brightest highlights vary across the composition. The range is extreme for the figures under the marquee, for example, whereas for the crowd in general, the tonal range is more subtle. By this juxtaposition of contrasts the eye is drawn towards the band and the surrounding crowd, while other dominant features in the composition are only suggested.

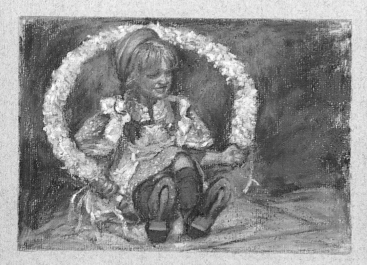

This girl with her hoop of flowers is an excellent subject for a study employing overlaid warm and cool colours. Note how the tonal contrasts are far less extreme than in the above scene. We are therefore forced to seek definition through contrasts of colour rather than tone. The overall effect is more impressionistic with less depth, but more colour.

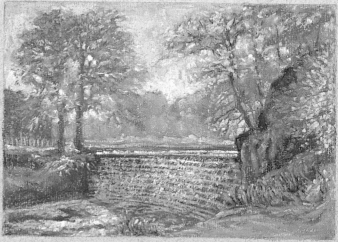

The underpainting for this study was completed entirely in complementary colours. Look for the reds beneath the green trees; pinks under light-green grass and browns under blues etc. The overall tonal range is thereby reduced even further, but the colour becomes highly excited by the complementary contrasts.

Using Pastels: At Home

(*Below left*) Working to this scale really brought back memories of Amsterdam and I began to remember the quality of light reflected from the water and the deep purples on bridges and buildings as the sun sank. Hopefully, this is reflected in the quality of light in my painting.

(*Opposite page, top left*) In a composition like this, with many overlapping planes, it is easier to start with the background and work forwards. I therefore blocked in the buildings that were furthest away using a blue to suggest distance. The sky, which was blended from a mid orange to a mid blue-green at its zenith, helped form the roof shapes. This sky colour was also reflected in the water. To control the perspective of the buildings on the left, converging lines of black were drawn across the building fronts and across the bridge to define it in a similar way. Some of these black lines were later overlaid with blue to add colour to these dark accents and to soften the roof of the building in shadow. The bright mid-orange sky colour was applied across the surface of the buildings to suggest reflected light. The colours were continually blended into the surface to achieve stability and softness. Changing tones of purple were used to depict the path on the right and the bicycles outlined in black to add interest to this otherwise rather dull area. The painting was again heavily fixed.

(*Opposite page, top right*) Returning to the sky, I again laid a graded colour from the skyline upwards, starting with a yellow and moving through green and finishing with a light, warm blue. I did this to create a change of hue, rather than tone, so that all the sky could be light, but with more intense colours near the skyline. By blocking in the sky, the shapes of the buildings, trees and bridge were themselves delineated. You can often use the 'negative' shapes around objects in this way to define them. The pastel marks were applied in many directions to give texture without losing the underpainting. Finally, white was laid over the yellow towards the bottom of the sky to give a glow of light through the trees. Details were added to the far buildings using cool colours so they retained their distance.

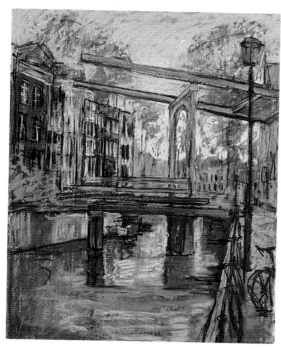

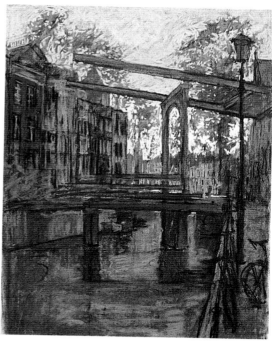

(*Below left*) I built up the buildings on the left using mid-tones, so they receded behind the slightly darker trees. To further this end, a tint of blue was laid over the whole block, using the side of a pastel, and worked in very gently with a finger. The trees in front were then scratched out with a scalpel to reveal the darker colours beneath, reinforcing them where necessary with a dark brown. The tree foliage was then blocked in and the picture gently fixed.

(*Below right*) My inclination was to finish off the buildings but I needed to balance their final colour and tone against

the white bridge. I therefore turned my attention to the latter, where I established its first layers with warm and cool purples and overlaid these with mid-toned yellows. This complementary layering created a coloured grey, which appeared white. Details were added to the bridge using dark-brown linework. Light blue under each beam and a yellow highlight on the rail were applied to suggest reflected light and sunlight respectively. Final highlights of yellow and yellow green were added to the foliage and the buildings on the left. Extra yellow was laid across the sky around the bridge to emphasize its purple colouring.

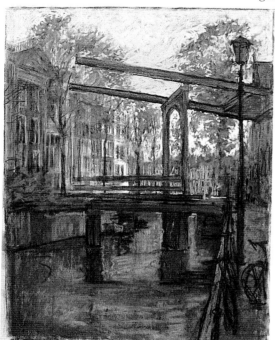

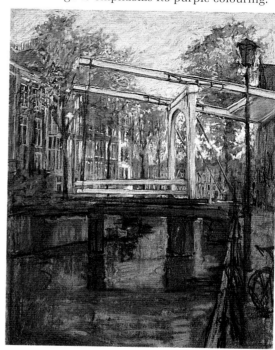

(*Continued on page 76*)

Using Pastels: Out and About

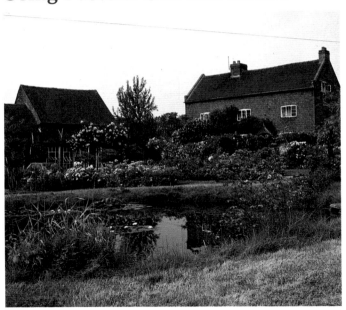

Many beginners are confused by reflections, yet they are simple to re-create. Go over the diagram (*below*), as well as looking at real reflections, and they will soon make sense. In figure 1, imagine that all the objects depicted are nearly all on the same level as the water. Ignore the limitations of the pond's dimensions and imagine it extended to the horizon or eye level (EL). The reflections (denoted by the blue dotted lines) now begin at the bottom of each object. Note the following: how the vanishing point for the buildings and their reflections are the same (follow the red dotted line): how and why Figure E is reflected (F), while Figure G is not (H): how the height of Buildings A and B differ (K) but not in the reflection. In Figure 2, again imagine the water extends to the horizon. Building edge A is now well above the water level directly below it (W1) and this distance must be reflected before the building line B can be drawn. Cloud C is in such a position that to reflect its distance from the surface (W2) places its reflection outside of the drawing completely. Note the following: the tree, although closer to the water than the house, is not reflected as it is at water level: the duck, being exactly on the water level has its reflection directly beneath. The roof R1 and its reflection R2 are slightly different shapes. Could R2 be the roof shape you would see from under the water surface?

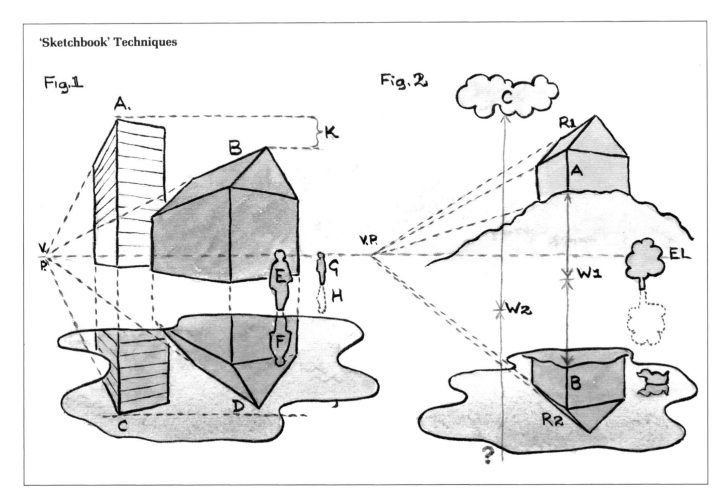

'Sketchbook' Techniques

Fig.1

Fig.2

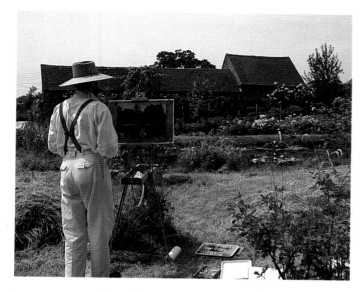

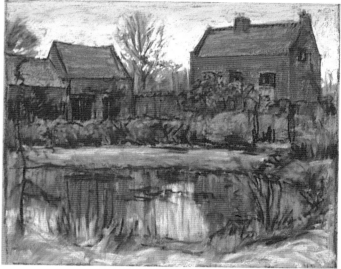

Here I am, well into the painting. Every so often a couple of giant dragonflies would sweep across the pond to have a look at me. It was either the hat or they had never seen an artist before!

(*Above right*) I used two greens for the foliage areas: a dark yellow green for upright foliage like the bushes which were blocking or absorbing light and a lighter, blue green for flatter surfaces which reflected the light. The colours from the buildings and sky were now applied to the water's surface to act as reflections. Note how the downward stroke of the pastel application gives depth to the reflection. Blending with a stub softened the marks.

(*Below left*) I laid a light pink across the sky, to reduce its intensity and to suggest the humidity of the day which gave a slight haziness to the sky. Distant trees were rendered in a light green and blue blended together. The roofs were highlighted in greys and scratched through with a

scalpel to produce fine linework at the edges. The brick-work was scumbled with a light blue in the shadow areas and with hot light oranges where it was in the sun. The white window frames were outlined in a light blue and, where the sunlight fell on them, overlaid with a light orange.

(*Below right*) A greater range of green tones was now established over the rose bushes. Those against the house were blended more heavily along with some of the window frames to knock them back. Lighter greens were applied to the bushes on the left, contrasting nicely against the dark building behind. On the right, the trees were kept dark to contrast with the light building. This balance of light against dark, dark against light, is known as counter-change. A layer of pink under the yellow- and blue-greens of the grass on the far side of the bank gave warmth. These bright colours were now brought down into the water and blended in with a finger.

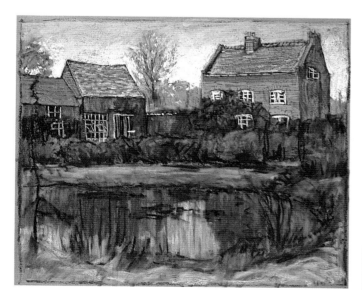

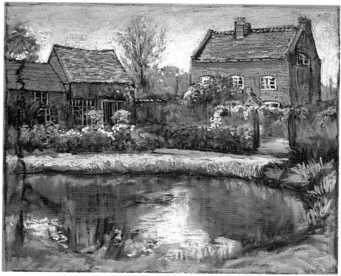

(*Continued on page 78*)

Using Pastels: Finishing Off

Stretch pastel paper for these final techniques by dipping in water. It is thinner and more absorbent than watercolour paper.

Dark underpainting: complete the initial drawing in a strong Indian ink line applied with a rigger or fine brush.

Alternatively, this line could be produced with a waterproof, lightfast felt tip or a brush pen.

Block in the masses with dark, dull washes of watercolour.

Build up a number of layers. Don't worry if the coverage is rough or incomplete. But do aim for dark tones.

Using the pastel edges block on dark colours.

Apply gently so the watercolour and line show through.

Colours can now be mixed on and blended into the surface with a stub. Alternatively, use your finger or a rag to achieve similar though less controlled results.

Apply fixative to stabilize the layer and to increase its transparency.

Lighter tones can now be progressively built up. Fix where and when necessary.

Alternating warm and cool colours makes the layering more visible and the colour more exciting.

Finish with heavily laid white highlights. Use a sharp knife or scalpel to shape and refine them.

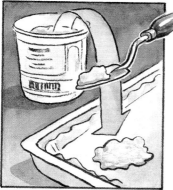

Textured underpainting: Texture or modelling paste is marble dust mixed with acrylic medium. Transfer a quantity to your 'stay wet' palette (*see page 120*).

Add a few drops of water to the container and close the lid immediately to prevent it drying out.

Tear off convenient lengths of masking tape and stick to your clothing (to remove excess tack).

Use these strips to mask the edges of a rectangle in which you are going to apply the texture. Don't exert too much pressure when sticking down the mask.

Apply texture paste with a bristle brush, painting knife or finger.

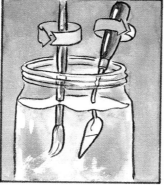

Keep brush or knife damp to prevent paste drying on either as it is difficult to remove.

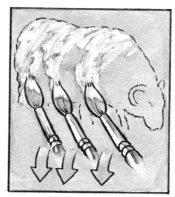

Use paste to model form and build up highlight areas.

Allow to dry – test dryness and solidity with fingers. Apply second layer, to create deeper, more irregular textures.

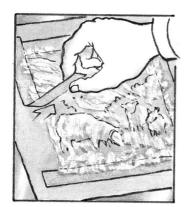

Remove masking tape before the paste dries and sticks it to the surface.

Paint dark colours over the dry texture with a bristle brush or force dark pastel into the textures with a stub or rag. Don't use sable brushes or your fingers, the surface will damage both.

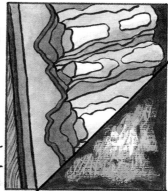

The heavy texture holds far more pastel than paper, allowing more layers of tone to be built up without fixing.

The surface structure works with the developing tones to create volume.

Finishing Off

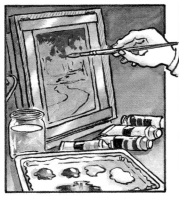

Acrylic underpainting: here the painting is first completed in acrylics using a very limited palette.

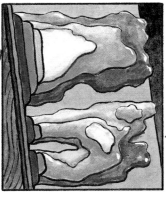

The acrylic can be built up in layers eventually achieving a textured paint surface with flat darks and textured highlights.

Try applying the acrylic with a bristle brush, finger, rag, painting knife, cardboard, stick, etc. Experiment by creating a variety of textures.

While the paint is wet it can be blended together with the brush head or scratched with the shaft of the brush (sgraffito).

Once the acrylic has dried, dark pastel colours can be applied (*top*) and blended into the surface (*bottom*).

This time when fixing takes place the increased transparency of the pastel allows the acrylic tones and colours to show through.

As the pastel layers become lighter in tone, fixing can continue to reveal underpainting.

In certain areas a shaped putty rubber can be used to selectively and softly reveal the dark underpainting.

Try rubbing the surface with sandpaper or a pumice stone . . .

. . . to reveal bright acrylic highlights through the softer pastel.

Note how a light pastel colour can be altered by the nature of the colour underneath, e.g. yellow over blue gives a cool colour, yellow over orange a warm colour.

If the colours become too bright try the occasional layer of grey to dull everything down.

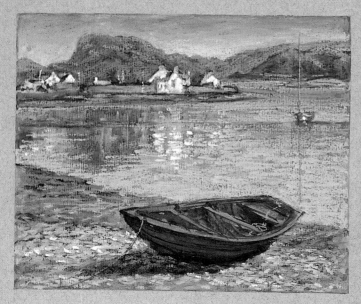

Mixed Media: Pastels with Watercolour
Here the dark underpainting in watercolour is overlaid with progressively lighter tones of pastel. The boat has the thinnest layer of pastel in orange, through which the line and watercolour can be easily seen. Note also how tiny dark accents of undercolour show through around the houses and the foreground pebbles, acting as a foil to the bright highlights in these areas.

Mixed Media: Pastels with Texture Paste
The effect of shimmering light in this study was achieved by underpainting with texture paste using a bristle brush. Dark accents were applied to the valleys of the texture, while bright highlights were applied to the peaks created by the brushstrokes. Their juxtaposition leads to strong tonal contrasts and vibrating colour.

Mixed Media: Pastels with Acrylic
Acrylic alone has less texture than texture paste (although they can be used together). It does, however, enable us to employ a full colour and tonal range before applying the pastel. This range can be seen emerging in the darker areas of trees and snow. Areas such as sky and water need a deeper build up of acrylic in order to hold the extra layer of lighter tones required here. The acrylic texture shows through the pastel and areas such as the water have a brush-like quality, not unlike that of an oil painting surface.

Using Pastels: At Home

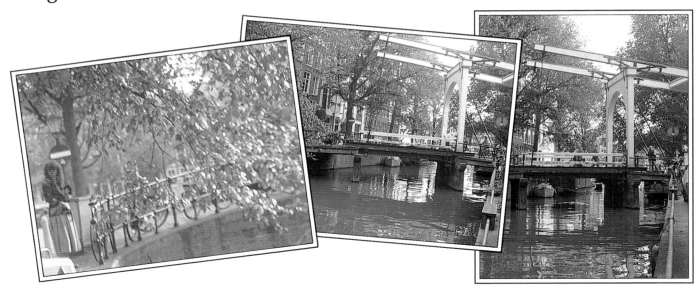

The building on the right was now suggested, mainly in cool colours, to prevent it dominating while the lamp was drawn in warm browns to pull it forward into the fore-ground. The floor of the bridge was overlaid with warm browns and its silhouette reshaped by applying cool blues into the negative shape of its background. Downward strokes of colour gave the first indication of reflections in the water, which towards the foreground became horizon-tal ripples. The bridge supports were given more form but kept firmly in shadow while the boats behind were given some warm highlights.

Highlights were applied to the bicycles and the negative shapes around them filled in with a mid brown indicating the path. Their edges were kept soft and unfocused by blending. The cobbles and bicycle spokes were suggested by scratching with a scalpel. The impression of brickwork on the left bank was created by converging lines drawn upwards and then downward strokes scratched through them with a scalpel. The boats under the bridge were light-ened and the colours dragged down into the water using a finger and stub to produce soft reflections. Finally, the fig-ures on the bridge were drawn as solid black silhouettes.

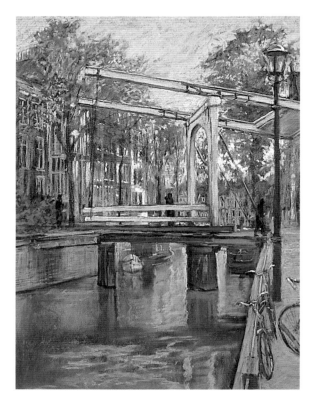

I managed to create differing tones of colour on the figures by applying the pastel using different pressures which allowed more or less black to show through. I emphasized the sunlight coming in from the right so it would fall across all the figures, separating them from their backgrounds. These figures were specifically placed on the bridge so I could make use of this tonal contrast against the surrounding colours. The sunlight also lifted the pavement colour. Highlights were applied across the water in horizontal strokes to suggest reflections. At first they were blended into the surface, but latterly they were left unblended, linking the feel of this area with the top part of the painting. These final highlights were left unfixed.

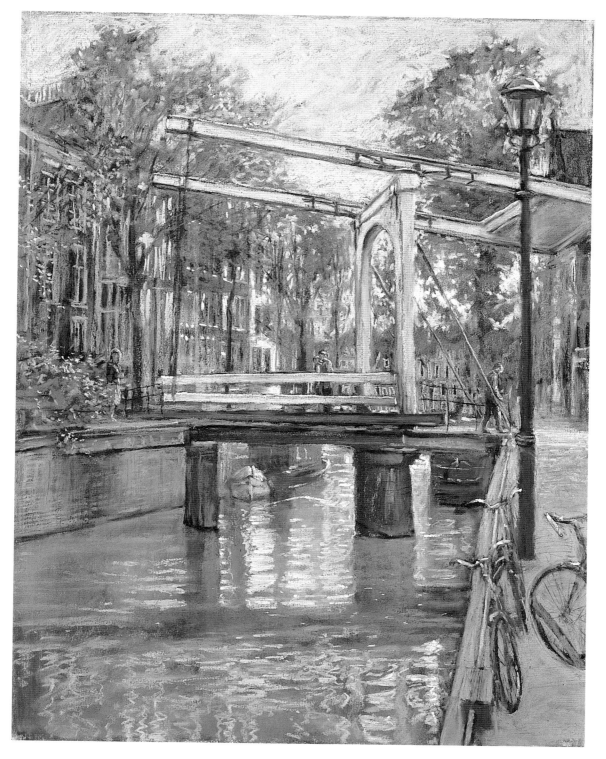

Using Pastels: Out and About

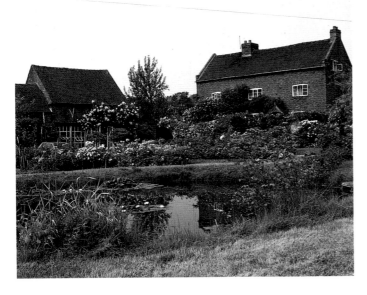

(*Below*) Roses now seemed to proliferate everywhere. Firstly, their positions were marked with cool colours or colours plus blue. Warm colours were overpainted to depict the sunlight catching the petals. Note, as an example of this cool/warm contrast, the roses to the left of the composition. On the building in shadow they are all cool. Even the pinks have blue blended into them. In front of these where the sunlight falls, the pinks are enhanced with warm yellows and white highlights. Look very carefully at which roses I have included and which I have ignored. In a complex painting such as this you can be selective, you are not a camera forced to render every detail. The water lilies were now laid across the pond's surface using dark to light-blue greens. The lily flowers were blocked heavily on and scratched off into shape with a scalpel.

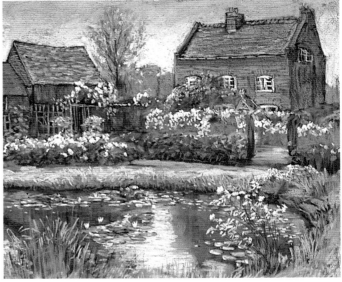

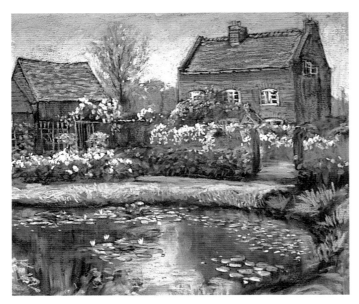

(*Above*) Foreground grasses and the rosebush to the right were first scratched out from the water surface with a scalpel and then accented with a dark brown. These areas were built up from dark to light and from cool to warm colours to capture the effect of sunlight. The roses on this small bush were carefully placed against a dark background to achieve the greatest contrast possible. Again, they were shaped by scalpel work. I laid a gentle pink across the foreground – a pleasant foil to all the greens here and to give emphasis to the foreground.

I placed more green highlights on the foreground grasses and added some light blues to the water peeping through the reeds which suggested that this mass was not solid. The dry grass in the foreground was worked up through mid to light, orange yellows. On the far right the grasses appear simply as a scumbled texture, but as we move forward I made the texture more suggestive of individual blades. Areas that were not rendered in these light colours begin to appear as shadows. The reeds also received some yellow lights while the seedheads overlapping the water

added more depth to the scene. The trees on either side of the painting, which act like a frame for the composition, were scratched off, accented and built up from dark to light. To retain their dominance, they were left unblended and their lighter features displayed against a dark backdrop of colour wherever possible. The house on the right, being a little strong was recessed by introducing light blue scumbles and linework to its surface. Its silhouette against the sky was also tidied up.

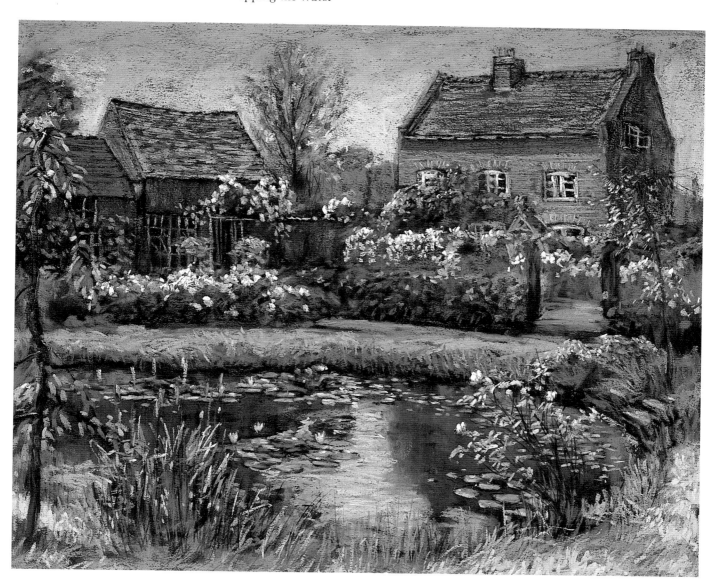

Using Pastels: Tricks of the Trade

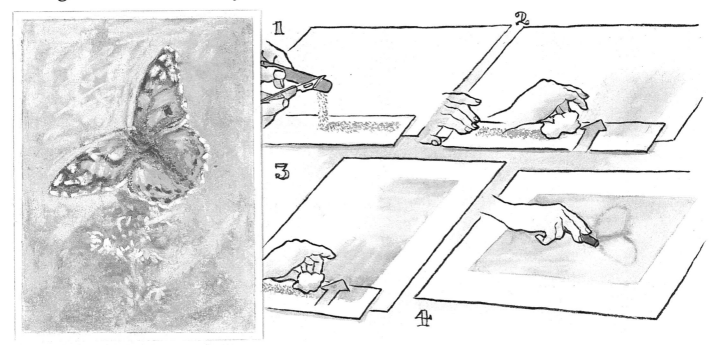

Here the pastel is laid as a gentle tone across smooth (Hot Pressed) watercolour paper by first scraping a quantity onto a strip of paper (1) and then working it across the surface (2) and (3). The rectangle of colour produced provides a wonderful shaded background on which to work. More of the same colour can be added and partially erased at the edges using a putty rubber (4). The result is a softly floating vignette. Other colours can be drawn into the surface.

Having created a soft-toned background using the above method you can use a series of paper masks to remove or add colour (1 and 2). The paper in this case provides the highlights. Other colours can be added (3) and/or the surface scratched with a scalpel to create highlights (4).

In this study (*see below*) all of the lightest 'whites' in the sky, snow and on the roofs were lifted off from a mid-toned blue base colour. Blues and browns were then drawn on to give the picture its darker tonal accents.

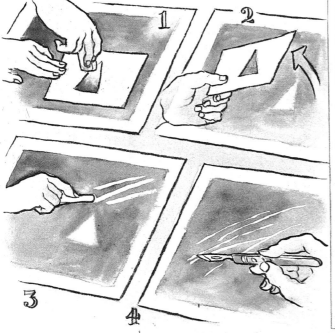

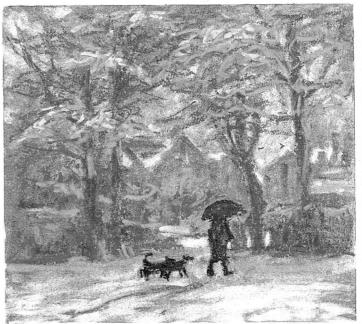

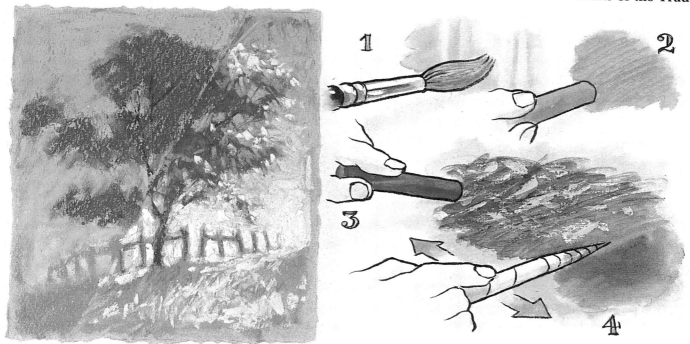

Opaque colours can sparkle if underpainted with their complementary. This can be laid on using paint (1) or pastel (2). The small accents left showing through the top coat give the latter a lift by contrast (3). If the underpainting is in pastel the two colours can be blended together in parts and will give grey or very dark, dull colours (4).

The study below illustrates an unusual method of my own invention. Cover the surface with many types of texture by applying texture paste with a brush, palette knife or card, etc (1). Add dark pastel colours and push into the textures with a paper stub (2). The pastel can now be partially removed with either a putty rubber, a pumice stone or sandpaper (3). This reveals soft lights or sharp highlights depending on the degree of lift.

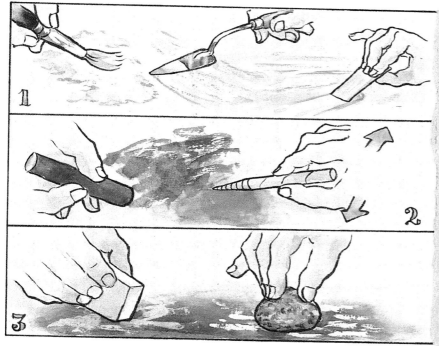

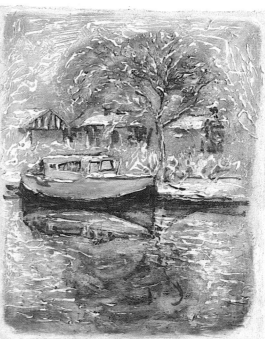

Using Pastels: Common Problems

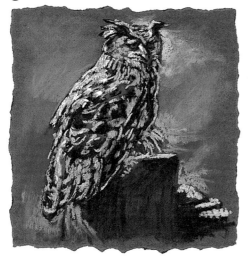

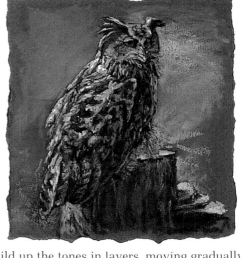

PROBLEM The highlight tones have been reached over quickly, resulting in too stark a contrast between the light and dark tones (hence the white looks white, instead of light brown), and all feeling of depth has been lost.

SOLUTION Build up the tones in layers, moving gradually from dark to light. This will result in a gentle gradation of colour that will give a sense of light and depth.

PROBLEM Overlaying the lighter colour has become difficult, resulting in a smeared, dark rendering.

SOLUTION Either (a) use fixative to stabilize the underpainting; or (b) use a different and more textured surface – experiment with different types of paper or board or apply a layer or texture paste to start; or (c) you may have accidentally mixed hard pastels with soft ones. Hard pastels require too much pressure to be applied over the soft type.

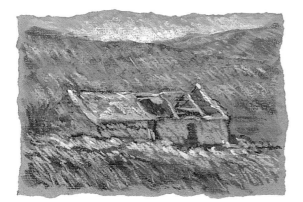

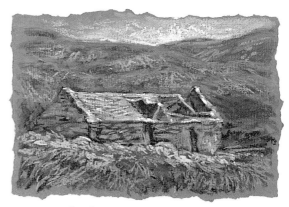

PROBLEM All the marks go in the same direction, carrying your eye swiftly across the composition and out the other side. This would perhaps be acceptable if you were trying to suggest rain.

SOLUTION Vary the direction of the marks. This keeps the eye within the composition and also helps to express form.

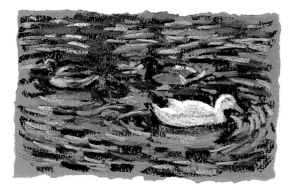

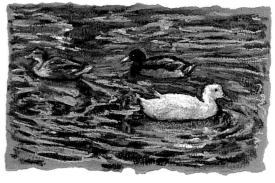

PROBLEM All the marks are the same size, creating a mosaic effect which is repetitive and dazzling to the eyes.

SOLUTION Use every part of the pastel to apply the pigment from its side to the tip, as well as snapping it into different sized fragments. The more erratic the mark the more natural it looks. Remember nature is itself irregular. Alternatively, use a stub to blend and loosen up the marks.

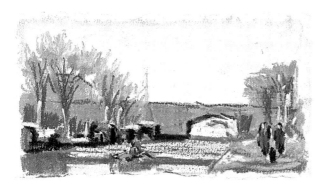

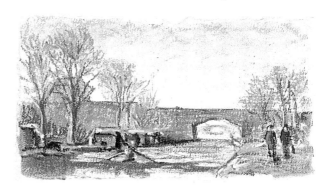

PROBLEM All the marks have been applied with the same pressure creating a flat effect with no variety.

SOLUTION Apply the pastels with a variety of pressures to achieve a more responsive and suggestive vocabulary of marks.

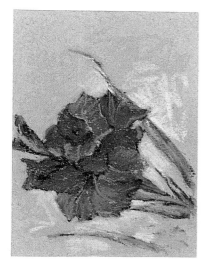

PROBLEM The negative space, i.e. the area around the flower, has been ignored as a positive element of the composition.

SOLUTION Imagine the negative space as a silhouette. If it has lots of bays, inlets and peninsulars it will excite the eye. Negative space is one of the most important elements to consider when forming your composition.

Oil Painting

When I first started painting seriously, over twenty years ago, it was watercolour that first captured my attention. I was fascinated by oils, but their thickness and viscosity put me off. The marks that I made seemed dull and lacklustre compared with the rich, inventive strokes of the great masters. Nor did my colour mixes bear any comparison – I could have been working in a completely different medium, the contrast was so great.

Obviously there was something in me that was lacking, or so I thought. The feeling of inadequacy was very strong and I have seen it in the eyes of many over the years. What I did not appreciate was that oil painting depends on the build up of layers. What I had so admired in the paintings of the old masters was the interaction of thick paint, known as impasto, against thin transparent colours, known as glazes. Lack of this knowledge meant that I could not achieve the results I was striving for.

Fortunately, I persevered and over time, and as the result of much experimentation and many, many mistakes, everything began to fall into place. All the qualities I had feared about oil painting became what I loved in it.

The stiff paint which had been difficult to apply, became the gateway to texture and allowed me the flexibility to change and mix paint on the painting's surface. The various mediums which had previously made the paint sticky and slimy now rendered it transparent and intense.

Many beginners choose to start off with oil painting simply because they are assured that any mistakes they make can be easily rectified. This is understandable as it is certainly a very forgiving medium which allows you to paint over or even scrape off any errors. However, it is more than this. Oil painting is about painting in layers to create depth. To stand before a Rembrandt, is to stand before a seemingly three-dimensional space filled with light; a true and lasting echo of times past. The work of such painters speaks to us on two levels.

Next time you have the chance, take a look at a painting by one of the great masters, study it carefully. You will be entranced by the light, space, mood and movement created by the artist's use of oils. But look at it on another level as well. Consider the abstract quality such a painting possesses. Look at the brushstrokes, the textures, the highlight areas and you will begin to understand the incredible versatility of oils and the excitement with which the artist must have applied the paint. I hope, by demonstrating how exciting and straightforward it is to paint with oils, to fill you with my enthusiasm for the medium.

In oil painting we have a medium which can be opaque or transparent; thick or thin in its application, thereby opening up a world of opportunities to employ a variety of brushmarks and qualities of paint.

The paint in its raw form, straight from the tube, is stiff, drying slowly to a permanent, hard finish. Overpainting of layers, whether on wet or dry paint, means that the artist

can work from dark to light and with colour on colour.

The surface of the painting, becoming a physical one, will start to affect light falling on it. Thick paint casts shadows and carries highlights – qualities which can be harnessed by the artist. Dark colours seem darker and deeper when laid flat, and light colours are brighter when laid on thicker.

With all these possibilities, you could be forgiven if you were to go no further. Often, those beginning in oils will work only to this stage. However, there still remains a level to which oil painting can be raised and which sets it apart from all other media. Glazing, the addition of transparent layers of colour to the textures developed in the early stages of the painting, enriches and enhances the surface quality of the paint. Glazing brings to oil painting that depth and richness we see in the work of the great masters. If you have struggled unsuccessfully in the past to emulate their paint qualities, it will probably be because you have not employed glazes.

The successful use of this technique depends on the two vital qualities that the medium of oil painting possesses. Firstly, oil paint as a naturally stiff medium creates the permanently held texture required for applying the glaze, without damage to the structure of that texture. Secondly, the glaze itself does not change in character as it dries. Both of these natural advantages make glazing in oil a rewarding and exciting technique.

As you can see, oil painting offers an immense range of qualities to the artist – from the endless variations of texture, up to the bright glow of textural highlights, through deep dark glazes. Its incredible versatility makes it suitable for a whole range of subject matters.

In portraiture, the ability to alter and change structure and detail is of supreme importance. As you study your subject, the subtle changes of mood and expression that occur can be selected and refined, until you have captured your subject's individual personality and characteristic features. While the building up of layers suggests the solid, yet yielding nature of flesh, in contrast the subtle use of glazes can be employed to convey the softness and opacity of clothing.

With landscapes, the layering of colours allows the structure of the view to be created first in the dull dark colours of an overcast day. Sunlight can then be suggested by selectively splashing highlight colours across the composition, enriching the surface and controlling the movement of our eye within the painting.

However, if flower painting fascinates you, then oil offers you unique scope. The colour in a flower head is very intense but this intensity is often lost when creating shadow areas and the flowers begin to look dirty. By laying glazes, the colour can be darkened in tone to suggest shadow areas and yet retain their rich vitality.

With seascapes and waterscapes, oil painting really does come into its own; with its transparency, intensity and layering, creating the depths and the surface qualities required. You need to convey a feeling of movement in water, whilst creating a surface sprinkled with sparkling light. The slow drying paint allows for the blending required initially; whilst the ability to work over dry, textured paint enables you successfully to achieve the latter.

Do, when you have built up some confidence, take your oils out into the field and paint outdoors. The first time I did this I learnt more about light and colour mixing than I had in years of previous study. For example, if you have just mixed a colour for a tree and suddenly the light comes out and hits the leaves, you will see for yourself the extreme change you need to make to your mix to achieve that feeling of light. Even if that is all you learn, it will be a worthwhile experience. However, once you have worked in the open air, I am certain you will become hooked. There is nothing more pleasurable than having spent all day out of doors, getting home, tired, but totally content with your day's efforts. And what memories your painting will evoke. Looking at it, even years later you will find the memory of that day clear in your mind, because of the visual concentration you put into the work. You will of course have also captured the essence of the day, by your own personal and careful selection of detail.

I remember one such occasion, which occurred years ago, vividly. Having worked all day in the rain, it was late afternoon and the sun came out for a very brief 15 minutes. I was able to sprinkle that sunshine through the wet leaves and create foreground interest with the shadows they cast. I could never have encapsulated the qualities of that day in a photograph, whilst it is still there to this day in my painting.

Oil Painting: Materials and Preparation

OIL PAINTS There is a staggering range of oil colours available and, like watercolours, they are available in Artists' quality and Students' quality. The pigment used in the Artists' range is known as genuine pigment, it is more finely ground than that found in the Students' range and contains less fillers. This means the colours mix more effectively and produce a smoother paint. When using paint directly from the tube it does not make much difference which range you use, although you will notice the difference when mixing thin glazes.

However, if you are approaching oil painting for the first time, I would suggest you start off with Students' quality paint. They are perfectly adequate for initial experiments and once you have gained some experience, you can then move on to the Artists' quality paints. Don't worry about wastage as you can mix the two ranges.

Start off with a limited palette (see page 127 for the colours I recommend) and experiment with colour mixing. These relatively few colours will produce almost all the hues and tones you will need.

GLAZING MEDIUM The traditional and most popular glazing medium is a mix of linseed oil and thinner. Its only drawback is the time it takes to dry. Modern developments have produced an alkyd resin medium which cuts down the drying time considerably and produces an equally fine glaze.

Be careful not to become too enthusiastic when applying glazes as if overdone, your painting will become too dark and overly textured. One way of avoiding this is to keep stepping back from your painting to check the overall effect your glazing is creating. But if you do overdo it, don't worry, as the glaze can easily be removed while still wet or alternatively you can leave it and overpaint the surface when dry. The colours you use will appear even richer if you allow glimpses of the glaze to shine through.

PALETTE For oil painting you will need a flat surface on which to lay out your colours. It should be made from a material that doesn't absorb the paints and is non-metallic as an unfavourable chemical reaction can take place between oil paints and metal surfaces. It should also be light enough so that you can hold it easily when out for a day's painting – you don't want to end up with an aching arm at the end of the day. Large balanced wooden palettes can be obtained and despite their size, are easier to handle than non-balanced makes.

When laying out your colours, I would suggest you work with a limited palette. This will not only be good for your colour mixing skills but it makes practical sense. If you try and use too many colours, you will end up putting a small blob of each one on the palette. This means that you will continually have to replenish your stocks of some colours, while possibly never using others. Whereas if you

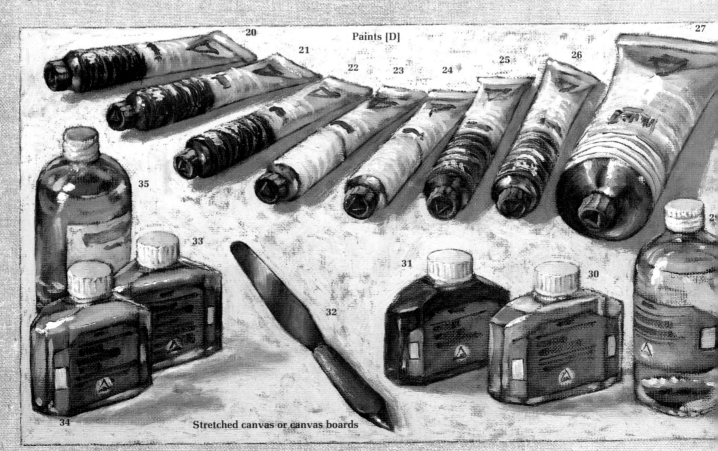

Paints [D]

20 21 22 23 24 25 26 27 35 33 32 31 30 34

Stretched canvas or canvas boards

have fewer colours, you can afford to put generous quantities on the palette. This will also help keep your colours clean as a dirty brush dipping into a paint deposit is less likely to leave colour behind if it touches just paint and not the palette surface. As soon as the latter occurs, the hardness of the surface picks up the colour from the brush and your paint deposit becomes soiled.

If you decide to buy the traditional elliptical artist's palette, you can lay out your colours in the formation of the colour circle (see pages 124–126). This simplifies colour mixing as you can see at a glance the position and bias of the colours.

Keep the centre of the palette clear for mixing. You can then just clean this area, leaving the remaining tube colour around the edge ready for your next session.

Some artists prefer to clean their palettes completely after each session, which of course wastes unused paint. If you are of this ilk then I suggest you transfer this unwanted paint onto a spare primed surface. Eventually a layer of paint will build up which, when dry, will form a very exciting surface on which to start another painting.

If you do leave the colour on the palette you can prevent it from drying in a number of ways. The simplest is to lean the palette against a wall, paint facing inwards. This traps still air between the palette and the wall, which should slow down the drying time of the paint. Alternatively, you can store the palette in an airtight container, even a carrier bag, or cover it with cling film. You could also try submerging it in water.

EASEL I really do believe that an easel is essential when working in oils. The upright position it affords your canvas allows an easy eye movement between the subject and the painting. Oil paint is so stiff it stays on the canvas even under the most difficult conditions, so working upright should pose no problems.

The easel you select needs to be stable and strong enough to withstand outdoor working conditions and aggressive painting techniques, but at the same time light enough to carry around when working in the field. It should also be fully adjustable to ensure you are working at the best heights and angles.

PAINTING SURFACE Oil painting can, and has been, used on all manner of surfaces from paper through canvas to metal and glass. The only proviso here is that where absorbent surfaces are employed they must be primed (see page 89). If they aren't, oil from the paint will be absorbed by the surface which can cause the paint to crack and the surface to deteriorate. Metallic surfaces also require priming to prevent chemical reactions with the paint.

BRUSHES There is a baffling array of brushes to choose from and the type you select will reflect the degree of smoothness, texture, or detail you require in your work. I

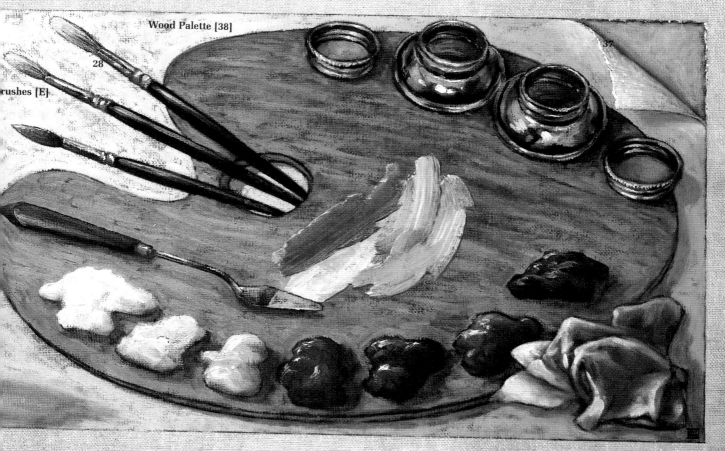

Wood Palette [38]

28

Brushes [E]

37

Materials and Preparation

would recommend that to begin with you start off with a few round bristle brushes as these are the most versatile and will allow you to experiment by applying layers of textured paint. These stiff brushes will not only pick up heavy paint but will make a unique fingerprint of every brushmark. These textures can be filled later, with glaze, enhancing and enriching them in a very distinctive way.

THINNERS Thinners are used for either mixing with paint, or for cleaning brushes and surfaces. The cheaper turpentine substitute or white spirit leaves a residue of oil behind on drying. Whereas this does not matter when cleaning, you do not want such impurities in your paint so the purer Artists' Distilled Turpentine is used for mixing. Distilled turpentine can also be used, its only disadvantage being its powerful smell. There are also odourless thinners on the market for those who are particularly sensitive to the smell or have an allergy to turpentine.

DIPPERS Thinners and mediums can be stored in dippers, which clip to the side of your palette for convenience or in jars. It is useful to have lids for both to keep them airtight and prevent evaporation or drying when not in use. Transfer a generous amount of the medium to these containers so that you can dip the brush straight in and out without touching the bottom or sides and discolouring the fluid, which could spoil later mixes. For the same reason, ensure your dippers have wide-necked openings.

PALETTE KNIFE A palette knife is useful for mixing colours on, or cleaning off, your palette. It can easily be over used.

Overmixing creates dull, lacklustre colours. You are less likely to overmix using a brush and although it can damage the hairs, I prefer to mix paint this way. Why not keep some old brushes for this purpose? The streaky mixes produced with a brush, mix visually on the surface of your painting and are much more exciting to the eye than flat, even colours.

PAINTING KNIFE The palette knife, which is spatula shaped, should not be confused with the painting knife which is trowel shaped and more flexible than the former. Painting knives come in many sizes with a variety of differently shaped heads, from long and thin to rounded or triangular, all of which give different marks.

The painting knife can also be used to scrape paint from the painting's surface. This is useful for both erasing mistakes and for scraping away at the surface to expose layers of dry oil paint. This can create textures and colour mixes unobtainable by any other method.

RAGS Save all your cotton rags for cleaning. They are much more effective than kitchen roll or paper tissue, as they do not disintegrate. Avoid any material, such as wool, which could deposit hairs into your paint and would not be absorbent enough to act as an effective cleaning cloth.

ON COMPLETION Always clean your brushes thoroughly after a painting session in the following way. First, wipe excess paint off on a cloth. Now swill the brush head in turpentine substitute or white spirit. Roll the brush head on the inside wall of the turpentine container to dislodge and dissolve paint at the base of the brush head. Now squeeze it in a cloth. You can roll the brush while squeezing, but *never* pull or you may dislodge the hairs. If you are continuing to paint with this brush then check there isn't excessive turpentine remaining in the brush by running it across the back of your hand. Any excess will thin out your paint making it difficult to control.

If you have finished painting completely then further cleaning is necessary. Wash the brush head out with soap and cold water. (Hot water would damage the hairs, expand the metal ferrule and melt the glue holding the hairs together.) Work the soap well into the hairs with your finger nail and rinse under the tap until the colour disappears. Flick out any excess water and reshape the head with your fingertips. Place upright in a jar to dry.

People watching my demonstrations often express surprise that I don't seem to clean my brush very often. The reason for this is that overcleaning can result in turpentine diluting the mixes, making them difficult to handle. In addition, the brush head needs to be well loaded with paint so it keeps its shape and not splay when used. If you keep cleaning the brush you will lose this build up of paint and have to refill the brush head. As the majority of the paint is applied using the outer surface of the brush head, this is a waste of paint. When I'm working with colours of the same family (all cool or all warm) I don't clean the brush in turps, but simply wipe any excess from the exterior of the brush head with a rag. If I wish to use a complementary colour then I do clean the brush with turpentine as I know that even a small amount of paint from a dirty brush will spoil the mix, especially if it is a bright one.

If you are working out of doors then carry your work home using canvas carriers (*see pages 52 and 53*) which will protect your work and are easy to use.

Finally, oil is a long lasting medium – the pigment being bound to the surface by an oil medium means it can resist the ravages of the environment, especially once it has been cloaked in a protective varnish. This is the final process and once applied (*see page 108*) it collects dirt and acid deposits which would otherwise damage the paint. Restoration is the relatively simple process of removing the varnish with its deposits and varnishing afresh.

Most surfaces (grounds) will absorb the oil (medium) from the paint causing dullness and cracking unless suitably prepared.

Ready-made (prepared) surfaces are available: 1. Oil paper (for sketching) 2. Oil board (oil paper on board) 3. Canvas board 4. Stretched canvas.

Preparing your own ground involves sizing to plug any surface 'pores' or 'weave'.

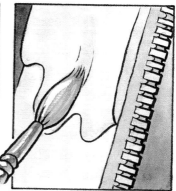

Then when the size is dry, priming – applying a layer impervious to the oil.

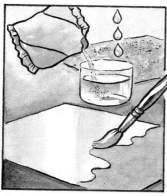

A cheap way of preparing your own ground is to size it with two layers of wallpaper paste. Dry out and sand between layers. Packet gives the correct mix.

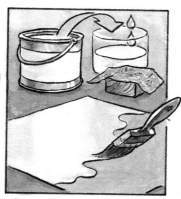

Then prime the surface with three layers of thinned emulsion. Dry and sand between layers as before. Use a 4cm (1½in) decorating brush to apply primer.

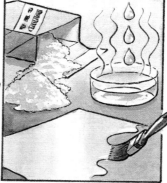

A more traditional method is to apply a size of rabbit-skin glue, available in granular form. Dissolve in hot water, cool and apply two layers.

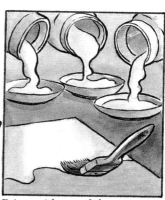

Prime with one of the many available brands: acrylic primer, acrylic gesso primer or oil painting primer.

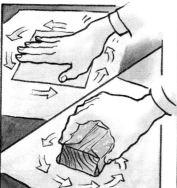

Don't forget to sand surface gently, in a circular motion, between layers. Wrap the sandpaper around a small block of wood for heavier sanding.

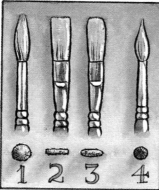

Oil Painting Brushes: 1. Round – bristle 2. Flat – bristle 3. Filbert – bristle 4. Round – hair.

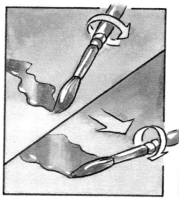

The most versatile is the round bristle brush: the point produces detail (*top*), the side blocks in masses and, for extra coverage and texture, it can be rolled or rotated (*bottom*).

Textures are produced when raw (thick) oil paint is applied using a stiff bristle brush.

Oil Painting: Starting Off

Oil paint is composed of two main elements: dry pigment or powdered colour . . .

. . . and a glue (medium) which fixes it to the surface. Traditionally, this is linseed oil.

In the tube the mix of ground pigment and medium is balanced to produce a thick, easily textured paint.

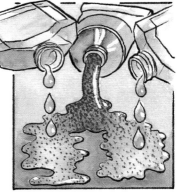

This can be adjusted by adding a thinner (artists' distilled turpentine) or more medium (linseed oil).

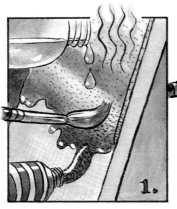

First layer (1): adding a thinner to the tube colour spreads out both pigment and oil and accelerates drying. **Second layer** (2): paint applied undiluted to the

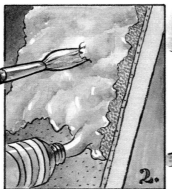

surface is easily textured. Its drying time depends on thickness of layer. **Glaze layer** (3): adding glazing medium to the paint makes it transparent.

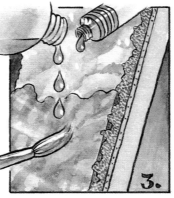

Note: for purposes of diagram only, mixing, which would normally occur on the palette, appears on painting surface.

The glaze collects in the paint 'valleys' created by the thick second layer and enhances the texture.

Always layer lean paint first, fat paint last, as in this way it dries naturally and consistently.

However, if lean paint is painted over fat paint, uneven drying can lead to cracking and a very unstable surface.

To start, create a sketching mix by combining cadmium red and ultramarine with just enough turpentine to make it fluid.

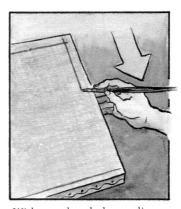

With your brush draw a line 10mm (⅓in) in from edge of canvas. This represents the area that will be lost when framed. The smaller the picture the more important this becomes.

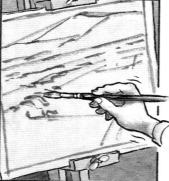

With your brush draw in a ske- leton grid of the composition from your thumbnail. Don't work too small. It is easier to work with oils on a larger scale to begin with.

Suggest the form of the overall masses. Don't overwork the detail or you will be reluctant to block on the colours.

You may prefer to complete this part of the 'drawing' in charcoal . . .

. . . or in pencil.

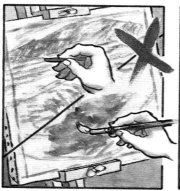

Don't be tempted to shade in areas. This is unnecessary and only mixes unpleasantly with subsequently applied colour.

If you have used charcoal for the outline stage, before adding any colour, tap the surface with a cloth to remove any sur- plus carbon.

Any remaining charcoal or pencil can be fixed to the sur- face with a drawing fixative.

Mix your colours dark and dull. Thin down with distilled turps.

Using your largest bristle brush block in the masses with this thin colour. This is the underpainting and it dries quickly as the thinner evaporates.

Be careful that the paint isn't too thin as it will run down the surface, erasing your original composition.

The underpainting can be app- lied using dull dark versions of the actual colours you see.

These dull mixes are achieved by adding their complementary colour, i.e. to green add a touch of red which produces a dull dark green.

Starting Off

Extra contrast can be achieved by underpainting in dull colours opposite to those you see.

This is achieved by using a mix further across the colour circle, a dull complementary, i.e. to green add more red to produce a dull dark red.

Or be adventurous and go the whole way . . .

. . . underpaint in bright complementaries, e.g. under green paint bright red.

Complementary underpainting creates contrast which can make overpainted colours appear more intense.

When all the surface is covered by your underpainting, take another slightly thicker mix of cadmium red and ultramarine using just enough thinner to make mix fluid.

Draw any extra details required into the wet surface. Hold the brush loosely at the end of the shaft to allow freedom of movement.

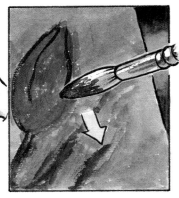

Using a large round brush you can get reasonable detail and it won't keep running out of paint.

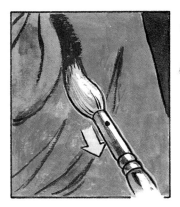

For rapid coverage, use the side of the same brush.

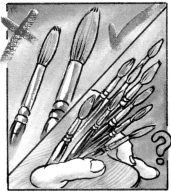

As a general rule, when deciding what size of brush to use, go for one three sizes larger than you think! It's versatility will prevent you ending up with a handful.

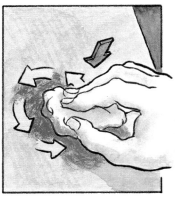

Alternative methods of underpainting include rubbing a thin layer of paint, without thinner, into the surface with a rag.

Or using a brush to apply a limited amount of undiluted paint by, again, rubbing it into surface. Note – this can damage the brush.

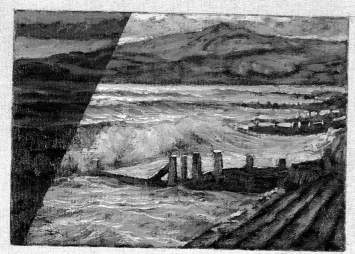

(*Left*) The top layers of each of the studies on this page have been painted using exactly the same colours. The underpainting, however, was carried out in different fashions. In this first example, the underpainting was applied using duller, darker tones of the colours used for the final layer. This was achieved by the restricted use of white and, where necessary, by adding complementary colours. Hence in the sky we see a mid brown, which was produced by mixing orange and blue, under the light, yellow-orange range. The tonal contrasts produced probably gives this example the greatest depth, although the colour is less interesting than in the other examples.

(*Right*) Again, the underpainting here utilizes dark colours, but the direct complementaries have been employed. Under green we have dark red, and under yellow orange we have a dark blue purple and so on. Thus creating both a tonal and colour contrast to the overpainted layers. The colours are intensified because of their juxtaposition with their complementaries. Look, for example, at the apparent richness of the greens on the hillside compared to the same colours in the first example.

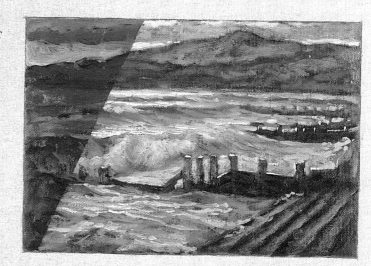

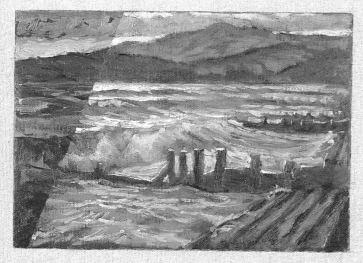

(*Left*) For really exciting colour contrasts, try underpainting in bright complementaries. There are no longer any dark accents and some depth is lost, but the colour begins to vibrate across the surface. This may not suit all subjects but it can make you much more aware of the colours you are using and the effects that can be created. This intensity of colour and loss of depth reflects the approach of the Impressionist painters.

Oil Painting: At Home

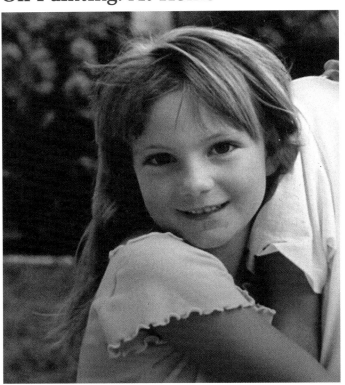

I have been approached several times by proud grandparents wanting me to paint a portrait of their very special grandchild. There are nearly always two problems. The first is that one cannot expect children to sit still for any length of time while you paint them and the second is that they often live some distance away. This picture, for example, is the grandchild of some very good friends, and she lives in the United States. The answer of course is to use photographs. It is far better if you can take these yourself, to ensure you have some close ups that capture a variety of expressions. You can also take written and visual notes in your sketchbook of details which the camera may miss, for example, hair and eye colouring. For this study my reference material came from the family photograph album, as I had not met the subject. A word of warning here, it's better to refuse a commission if you don't have access to a reasonable reference shot. The photograph that was best for my painting also featured two other children. My thumbnails demonstrate how I coped with this problem. You will also note how my canvas size dictated the proportions of the study.

(*Opposite page, top left*) You can see from this studio view that I have not been over ambitious with the size of the portrait. Apart from the fact that I prefer small studies, it is also foolhardy to attempt anything too large when you only

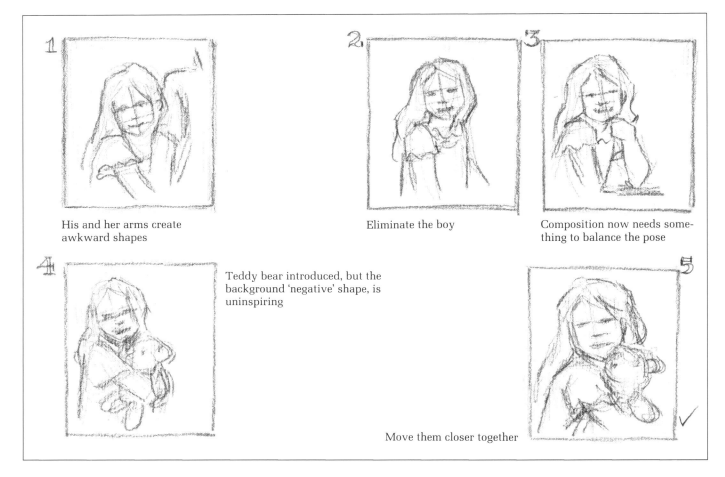

His and her arms create awkward shapes

Eliminate the boy

Composition now needs something to balance the pose

Teddy bear introduced, but the background 'negative' shape, is uninspiring

Move them closer together

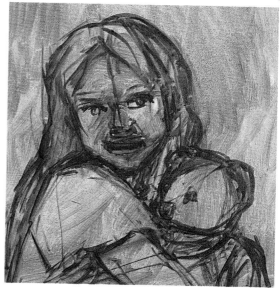

have a small reference shot. The photograph pinned to the top of the easel shows the restrictions I had to work under. (*Above right*) Firstly, I covered the whole surface with a layer of mid brown – I used plenty of turps in the mix. This took away the brightness and starkness of the surface and it was pleasant to work into a fluid surface on which corrections could easily be made. I outlined the area that would be lost under the frame and drew in the figure using cadmium red and ultramarine.

(*Below left*) I continued in dark complementary colours, thinned with turpentine. Applying green under flesh tones is a very traditional practice and gives depth to subsequently applied flesh colours. Another advantage of such a complementary layer is that you're unlikely to achieve any pleasant accidental effects that you will be loathe to paint over. An underpainting is meant to be overpainted and if it is in a shocking colour, then all the better. I then redrew any detailed linework that was necessary. The bottom of

the painting was softened to create a vignette effect so the emphasis was redirected away from the diagonal of the child's arm to the silhouette of the bear's arms.

(*Below right*) Working from the back of the painting, the space around the figure was filled with streaky, textured paint. Counterchange was effected by placing dark tones against the light edges of the face and vice versa. The overall coolness of the background colour ensured it receded and by working some of this colour into the base of the figure, the vignette effect was heightened. I worked some warm, mid-toned colours thinly over the flesh allowing the green underpainting to show through and then applied a lighter version of this colour to give form and structure to the face. Warm grey blues were added to the whites of the eyes, the teeth and top of the shoulder. A cool blue reflected highlight was introduced down the child's back. Finally, I dragged a dull brown across the bear's fur and a dull red for his jacket.

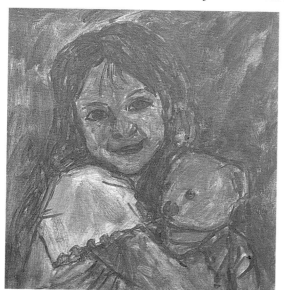

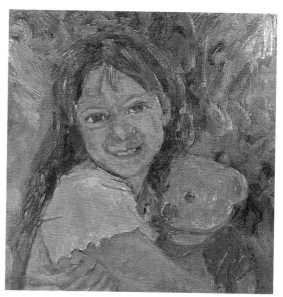

(*Continued on page 102*)

Oil Painting: Out and About

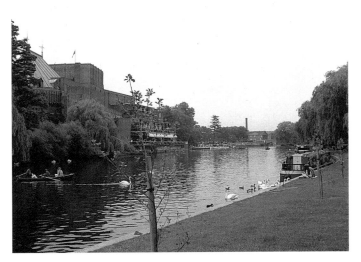

I had visited Stratford-upon-Avon several times before on painting expeditions but I had never managed to capture this particular view showing the river and the theatre. It seemed rather a daunting task at first; the view had many enticing focal points, but the large masses were generally uninteresting, for example, the huge wedge of sky and the grassy area in the foreground. Added to this was the fact that the day was overcast so there was no sunlight to break up these solid masses. This, however, was not a problem as I could introduce sunny highlights at a later stage and use my thumbnails to recompose the view in a more balanced manner. The proportions of the thumbnails were restricted by the proportions of my canvas. In fact, I drew up a number of empty rectangles to the right proportions, in my sketchbook before I left home (*see page 10*).

It was interesting later in the day, while walking around the town, to note that, although this is obviously one of the most memorable views of the river, there were few postcards featuring it. Unfortunately for the poor photographer, although he has any number of lenses to play around with, he cannot recompose a view in the same manner as a painter.

Too much sky and the central area is too cramped

Centre less cramped but the sky is worse

Try a different format – whoops!

Better, but left bank still too crowded

That's it, lots of room on the river for reflections and boats

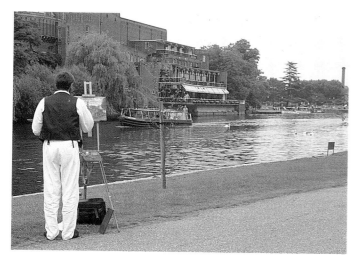

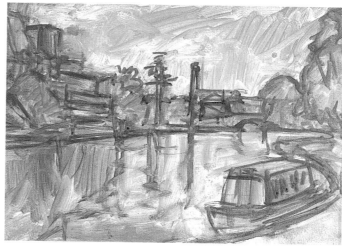

What a wonderful scene to paint. The light on the water was constantly changing and the flow of traffic up and down the river added further interest. There were also many curious onlookers and, in a situation like this, you have to be gregarious. The best comment of the day came from a lady who murmured to my wife, 'I've never seen anyone wear so much white for painting, but never mind, at least he's having a stab at it.'

(*Above right*) I drew in the main masses from my thumbnail and could already see the interesting 'negative' shape the sky now made. The water dominates a huge area but will be filled by the movement of boats and reflections. This linework was then filled in with colours complementary to those that I could actually see in the view. This brightly coloured start excited my imagination on such a dull day.

(*Below left*) I loosely applied some dull colours which would act as a contrast to the sunlight I intended to introduce later. It is important to paint on such colours roughly so the underpainting shines through. This not only adds excitement to the colour, but the thin layer achieved by

rubbing on (*see page 92*) is easily overpainted. To make the sky shape even more irregular and interesting a light blue was applied, leaving some diagonal cloud shapes exposed. The blue became even lighter towards the horizon to give depth. This feeling of depth and distance was reinforced by blending such colours with a large bristle brush. I then redrew some of the linework and added two boats on the left-hand side of the river to give focus in certain key areas. Always carry a small sketchbook with you so fleeting details, such as these boats, can be captured and used later if needed.

(*Below right*) I now decided to give a feeling of sunlight by adding warm lights to the right side of the distant trees and buildings. Against these the light tone of the sky was blocked in using Phthalo blue to give the intensity of blue found in summer skies. I then used a medium to light orange to add highlights to the cloud formations. The placing of these highlights, again irregularly, helped to bring interest to the sky masses by breaking its monotony.

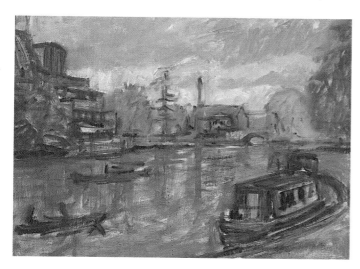

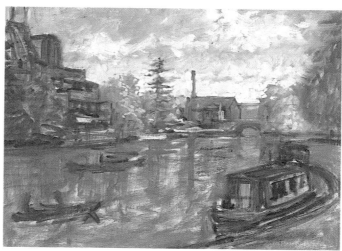

(*Continued on page 104*)

Oil Painting: Techniques

Second layer: thick textured paint is applied without any thinners or mediums.

For extra heavy textures, the fluidity of paint can be reduced by spreading it on paper (newsprint) which soaks up the oil leaving the paint drier and stiffer.

When sufficient oil has been absorbed from the paint, scrape it off the paper and return it to the palette ready for use.

The object of the second layer is to gradually build up the stiff paint to give dark and light tones, creating the painting's structure.

Start with a dark colour for the accents. Only small quantities are mixed. Fill two thirds of brush head thinly with stiff paint.

Apply the paint at a flat angle with the side of the brush head.

It should be worked into the surface using little paint. This creates a smooth thin layer of stiff paint which can be easily overpainted while wet.

The second mix is lighter and greater quantities are required. Generously load the brush with paint so textures can be made.

When the brush carries more wet paint than the surface then the paint flows freely from the brush onto the surface; the secret of wet-on-wet oil painting.

However, if the surface holds more wet paint than the brush, then the brush will lift more paint than it deposits – frustrating!

Rotate the brush head in the paint mix to ensure it picks up an adequate quantity of paint all over. Note the angle at which it is inserted into the mix.

Apply the second mix with the brush forming a less acute angle to the surface. The reduced surface area covered by the brush head allows for greater detail to be applied.

After a few brushstrokes the colour on one side of the brush runs out.

Revolve brush to bring a new side of the brush head, with its fresh paint supply, in contact with the surface.

Continue until the brush has yielded all its paint before applying more to the brush.

This technique ensures fast and adequate coverage of wet paint. Avoid applying too much as total coverage can be very uninteresting.

The third mix is applied even more generously. The brush should now drip with paint as it is transferred to the painting surface.

Increase the angle of the brush to the surface for finer brush work. Take care that the brush does not touch the surface, you should be painting with the paint itself.

Drag a well loaded brush swiftly across the textured wet paint, catching the peaks as you go – this is scumbling. Keep the brush flat to prevent paint deposits in the valleys.

Scumbles are even more effective if laid over dry paint and much less paint is required.

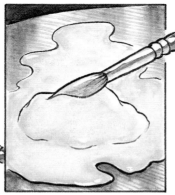

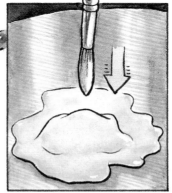

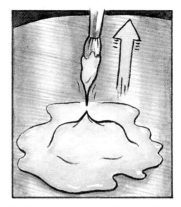

When you have completed a mix, scoop up on mixing brush and deposit by rotating head on surface to create a small mound.

This creates a deep deposit in which to dip your brush and enables you to pick up more paint. Also by not touching the palette, even a dirty brush will not soil the paint supply.

If you wish to apply a highlight colour dip the brush head into this mound directly from above.

If this is retracted with speed you will find a spike of paint protruding from the brush head.

Techniques

This spike can be used to deposit your fine highlights.

This magnified cross section shows how textured paint catches and reflects light from above.

Alternative methods of applying paint: undiluted paint can be applied with a painting knife, producing a smooth deep layer.

A similar effect can be achieved using a piece of cardboard cut to size.

Or the paint can be applied straight from the tube.

For detail work, grip the brush near the brush head, presenting the brush point to the surface.

Use an overhand grip to bring the side of the brush head into contact with the surface for wider paint coverage. It is also easier to rotate the brush using this grip.

The overhand hold also allows more freedom of movement and the brush can be drawn in the direction of the required brushmark.

The hard edges of a brushmark can be blended (lost) into wet colour beneath using a clean dry brush.

Blending across, rather than in the same direction as the edge, is more aggressive in moving the paint but may overmix and lose detail.

Your clean brush will soon soil and will periodically need to be wiped on a dry cloth or it will start to transfer paint. Don't add any turps.

The thicker the paint the more gentle the blending required. Try different brush types – bristle, nylon, sable, etc.

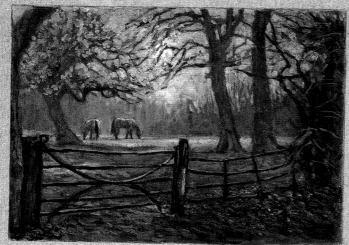

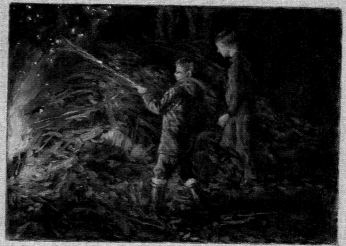

Limited Palette: an excellent method for concentrating your mind on the tonal range of a subject is to complete a painting using a limited palette. Here, for example, the colours were restricted to burnt umber, ultramarine and titanium white. The balance of brown and blue allowed either a warm, cool or neutral bias in the mixes. Adding, or not adding, white yields the tonal contrasts. A further refinement to this technique would be to overlay a series of glazes.

Blending: a painting in which the focus is soft allows our imagination to play an important role in creating detail. In this study the backdrop of partially illuminated trees and the complicated ground cover have been reduced in detail by blending. Look at the difference between the front of the figures, which catch the light sharply, and their backs which practically dissolve into shadow. Notice also how the sparks from the fire, the sharpest points in the painting, stand out against a blended background.

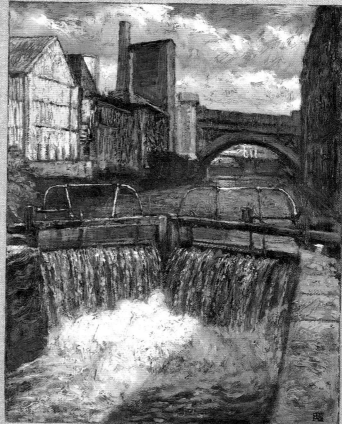

Scumbles: to exaggerate the scumbled textures in this study, it was first underpainted with thick paint in colours complementary to the final colours. In the sky, for example, you can still see glimpses of the orange underpainting. Further emphasis on texture was established by glazing. Finally, the scumbles were added and, with the help of the underlying paint structure, all the brushmarks were broken up to give a wonderfully textured effect. Most of the scumbles were laid light over dark, the easiest option, with the notable exception of the dark building on the right.

Oil Painting: At Home

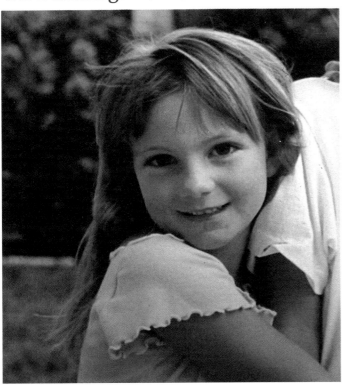

The 'sketchbook' techniques below show how the proportions of the face change according to our age and sex (*see diagrams 1, 2 and 3*). The position of the eyes (a) is halfway down the head, lower in the case of the child. The fall of hair across the forehead often gives the impression they are higher. Proportions b and c vary considerably and need to be observed keenly. In the male (1) I have given b, c and d equal proportions, but in the female (2) and child (3) d becomes smaller. This variation of chin proportion (d) has a logical explanation. In young children it is undeveloped and remains partially developed in the female while the male chin becomes very strong. It is this feature along with the width of the shoulders, that indicates the sex and age of our subject. If you view the head in three-quarter profile (*diagram 4*), note how the axis (indicated by the blue line) of the egg-shaped head is no longer upright. The neck does not perch on the shoulders, but moves forward at an angle. This obviously alters the positioning of the head so that it juts out in front of the torso. We therefore see a lot of space over the figure's right shoulder, but hardly any over the left (*see orange arrows*). If the subject looks up or down (*diagrams 5 and 6*), we then have to deal with the problems of a tilted head. Children often tilt their heads and the new alignment of the features must be accommodated. Diagram 7 shows how to cope with this situation. In our picture the girl looks straight at us, but has her head tilted (*diagram 8*). Compare this sketch to the actual painting and then try to duplicate it using your own subject or copy the one here.

'Sketchbook' Techniques

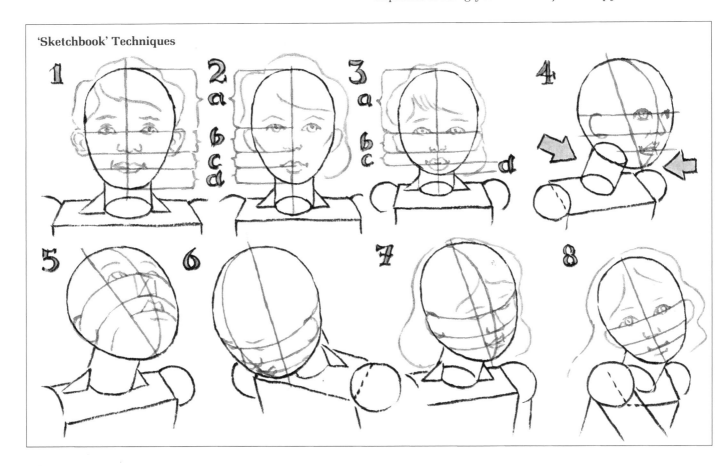

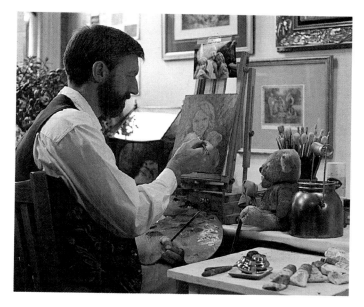

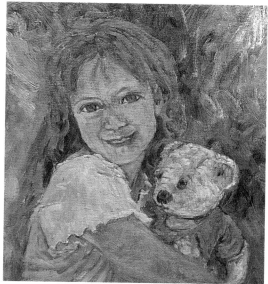

Further into the painting and I seem to be working under the watchful eye of the teddy bear. Could be a difficult customer if I get the likeness wrong!

(*Above right*) Moving onto the next stage, I applied a lighter, but still dull orange, down the left-hand side of the face to highlight the area around the eyes, the left-hand side of the nose and to shape the mouth. The fine linework around all the features was re-established. Re-drawing such as this can be done periodically throughout the painting and is eventually lost or softened into the large brushmarks. Medium-brown horseshoe shapes were drawn around the pupils suggesting light in the eye. I used cool brown strokes drawn in the direction of the hair flow to give emphasis to its structure and applied a similar, but lighter, set of brushmarks to give volume to the teddy bear. Any hard edges were softened both in the hair and fur. Cool and warm highlights were added to the bear's jacket.

(*Below left*) Using the point of a nylon round brush, I then applied cool highlights to the lower half of the eyes and a warm highlight to the bottom of the horseshoe-shaped irises. I accentuated the reflected highlights on the face and hair and by carefully blending them into the previous colours kept them subtle. I then applied a cool highlight to the shoulders, catching the scalloped edge of the sleeve.

(*Below right*) I continued the highlighting process by introducing a light blue into the whites of the eyes and the teeth while the addition of a light pink softened the lips, nostril and bottom eye line. By using this same colour down the right-hand side of the face and arm, I began to suggest the strong light that was coming from the right. To emphasize this further, I scumbled a light yellow over the hair on the right and a very light blue purple onto the shoulders and scalloped-edge of the blouse. I then added highlights of orange and blue to the bear's eyes.

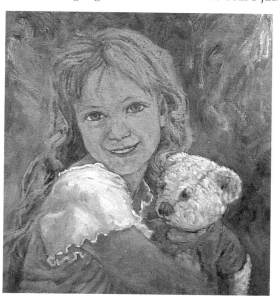

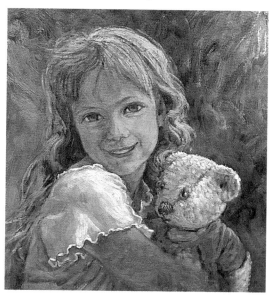

(*Continued on page 110*) 103

Oil Painting: Out and About

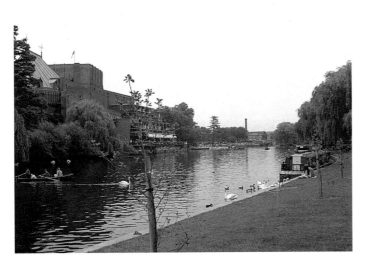

In the diagram below you will see that the pencil appears shorter as it swings around to point at the observer. This phenomenon, known as foreshortening, will crop up time and again in your studies.

Look at the rectangular box, below the pencil, and note the effects of foreshortening as it swings around. You'll notice how the blue lines become shorter while the red lines become longer. A good way to familiarize yourself with this concept is to set up some books and cardboard boxes and draw them from a variety of positions. Your paintings, however, will often contain more complicated objects than boxes, such as the barge in the painting. But don't be put off. Draw a large box as before and divide it up. Then draw your object inside the box and you will automatically create the correct foreshortening effect as you can see from the diagram of the barge. Try this with a number of objects and very soon you will start to see complicated objects in a more simplified way. As you begin to strip away the unimportant detail from an object you can begin to understand its three dimensional form more easily and this will enhance your drawing and painting immeasurably.

'Sketchbook' Techniques

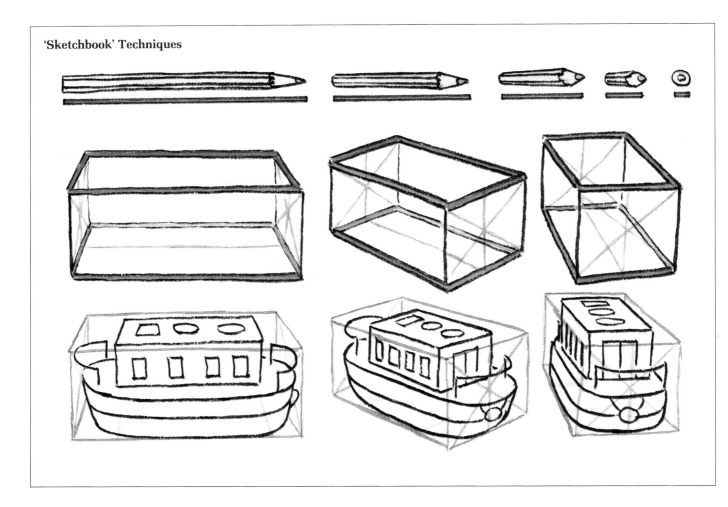

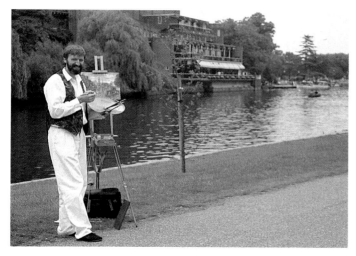

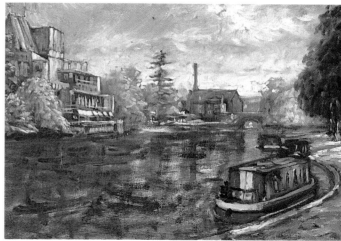

I was very happy, but unfortunately the weather conditions were deteriorating and it was getting very dark. Much as I was enjoying myself I had to call it a day. I achieved the main structure of the painting and knew exactly where I wanted to go with it, but unfortunately I'd run out of time. Still, I had plenty of sketches, my thumbnails and I'd taken some reference shots with my camera so even if I couldn't return at a later date I still had enough information to finish it off in the comfort of my studio.

(*Above right*) I felt the clouds were a little harsh against the blue sky and so I blended the edges and created a softer effect to give movement and depth. In contrast, I painted the trees on the right with a cool dark green which I lightened as the trees receded into the distance. Beneath them, sunlight was streaked across the grass in a series of parallel strokes. This achieved both contrast and divisions within this otherwise boring shape. Using warm colours, I created the effect of sunlight catching the face of the theatre and the trees surrounding it. Rich green horizontal strokes were then laid down through the water to suggest the deep dark reflections of the masses along the water's edge.

(*Below left*) I now suggested the lighter reflections of the sky and tree highlights with horizontal brushmarks of blue and light green. These were blended at either end to suggest the softness and movement of the water's surface. The white boats, in mid stream, were established using light grey blues and their reflections beneath using the same colour.

(*Below right*) Along the far bank, I picked out the strong highlight colours of the trees on the far left and the yellow blinds, outside the theatre, and suggested their reflections in the water's surface using horizontal brushstrokes. The figures and some details on the boats were suggested using blocks of mid-toned colours. I made the ripples in the immediate foreground much larger to suggest their close proximity and by using a mix of Phthalo blue and Prussian blue, gave them an added intensity even though they were already a light tone. It was at this point that the light and weather conditions deteriorated to a degree which forced me to return to the studio to complete the painting.

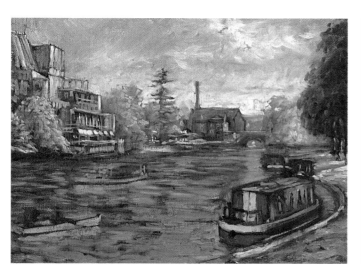

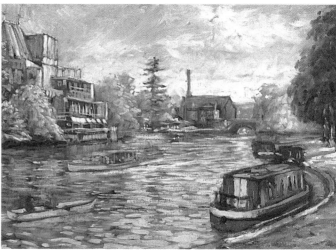

(*Continued on page 112*)

Oil Painting: Finishing Off

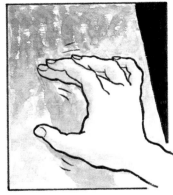

All the techniques up to this point can be completed by working paint into and over wet paint known as alla prima. This is excellent for working out of doors.

To continue, we must first let the paint dry. This can take days or weeks, depending on the colour and its thickness on the canvas.

So it's worth having more than one painting on the go at once – or intersperse your oil painting with a few watercolours or pastels.

Glazing: before you attempt this technique, test the surface of the painting with your finger to see if it is dry.

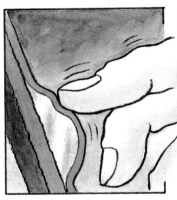

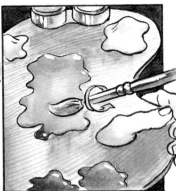

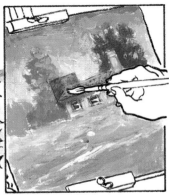

It doesn't have to be dry all the way through, but you must be certain that you won't break through the skin (shown in the cross section).

Transfer some glazing medium to your palette.

Add a small amount of colour and mix the two together.

Paint this mixture very thinly over your painting, covering an area approximately 5cm (2in) square.

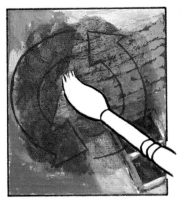

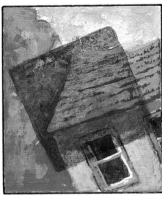

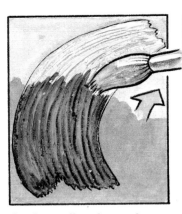

Work it well into the surface textures.

Note the way the undercolours are affected by the glaze. Colours of the same family intensify; complementary colours become duller and overall all colours darken.

The glaze will settle into the dry, textured brush marks of earlier layers.

Every texture is enhanced in this way, even that of the canvas ground will be strengthened where it shows through.

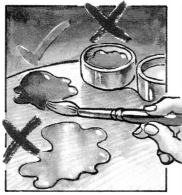

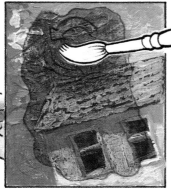

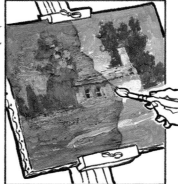

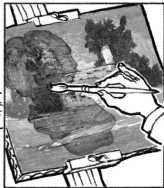

If you wish to add more of the same, or even a different colour, to your glaze use it straight from the tube. Don't add any glazing medium.

Work it into the wet glaze employing the medium already on the surface.

A glaze can be painted lightly over the whole of a painting to hold the colours together (mix a brown, and glaze with this).

Alternatively, it can be laid in specific areas and/or blended into other glazes on the surface.

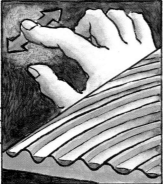

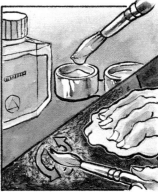

Try out all your colours as glazes. Note how their transparency varies and how they affect underlying colours.

Lifting wet glazes: firstly, rub your fingers across the surface. This will lift the glaze from the peaks created by the paint textures, but allow it to remain in the 'valleys'.

To lift more of the glaze rub the surface with a cotton cloth – avoid using slubby or loose-haired fabrics.

Interesting contrasts can be achieved by working a small quantity of glazing medium into the wet surface and gently wiping off again.

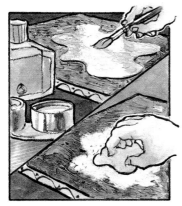

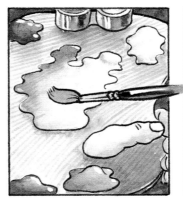

For complete removal, lie the painting flat. Brush artists' distilled turpentine onto the surface and into the textures. Remove with a soft cotton cloth and apply a coat of retouching varnish.

When dry, glazes can be overglazed successively with other colours. The common layering pattern is to lay cool glazes over warm ones and vice-versa. Experiment!

Tinting: the addition of white to a glaze produces a tint. Zinc white is the best white to use as it is the most transparent.

I often think tints are difficult because when first laid they can seem to be over heavy, covering up all detail . . .

Finishing Off

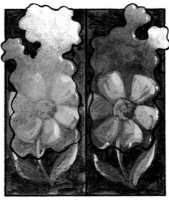

. . . you must therefore work them into the surface like a glaze.

The volume of white in the mix controls the opacity or transparency of the resultant colour.

Tints lighten and soften and can be used to reduce the strength of an area causing it to recede.

They can be strengthened or removed in the same manner as glazes.

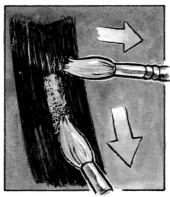

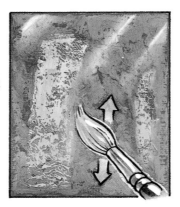

Scumbles: these can be laid over glazes or tints, wet or dry. Note the different effects created by scumbling with, or against, the surface texture.

Scumbles can be partially blended into wet glazes beneath. The resultant mix is a tint. We now have glazes, scumbles and tints in one layer.

Tonking: this is employed to soak oil from the surface to stiffen the paint so it can be reworked more easily. It also creates its own special finish.

The oil is absorbed by using either tissue paper or newsprint.

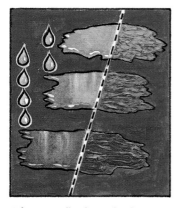

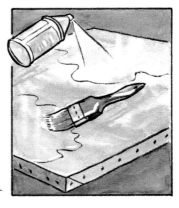

The more fluid or oily the mixture the more easily it will lift from the surface.

Varying the pressure applied to the paper will also change the degree of lift and thereby the resultant transparency. Take care to support the back of the painting when applying heavy pressure if using canvas.

Varnishing: this prevents uneven shine on the surface and protects the painting's surface. Retouching varnish can be used on freshly dried paint.

When the painting is completely dry, which can take from 6 to 12 months, use finishing varnish. Applied in liquid or aerosol form it needs about 3 thin coats. If overdone it may run or pool.

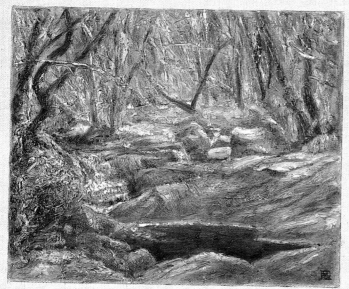

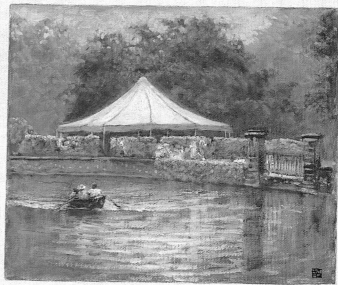

Glazes: knowing that the colours and textures in this study were to be achieved through the use of glazes, I built up the underpainting in a light toned, thick impasto paint. In fact the underpainting contained so much white that it had a chalky appearance when complete. A number of glazes were then laid. It took several days even though I was using a quick drying glazing medium in the mix. For maximum richness, texture and depth, I applied warm glazes over cool ones and vice versa. Look, for example, at the dark green pool in the foreground which began as a light blue. It was overpainted with warm as well as cool glazes. The painting was completed with the addition of a few scumbled highlights over the background trees which shimmer against the richness of the glazing.

Tinting: the moist, atmospheric effects in this study have been created through the use of tints. They are most obvious in the background, particularly across the central red tree. They were also used to make the hedge recede above the wall and behind the picnickers. The figures in the boat appear to come forward, out of the painting, because a tint has been painted carefully around them to make the background recede. All these tints were blue, but above the tent an 'off white' tint was laid to suggest the light bouncing off the canvas top.

Tonking: several tonked layers were employed in this study to create the effect of sunlight on a rain-stained window. This window area was first painted quite darkly with a grey blue to suggest depth and allowed to dry. The first mix for tonking was a light yellow orange. It contained enough glazing medium to make it semi-transparent and easy to remove where necessary. A second mix had more white and less medium and remained as the more solid raindrops when partially removed by tonking. Note the dark crosshatched areas on the window and frame. These were made by pressing a fingernail into the paper during the tonking process (*see opposite page*).

Oil Painting: At Home

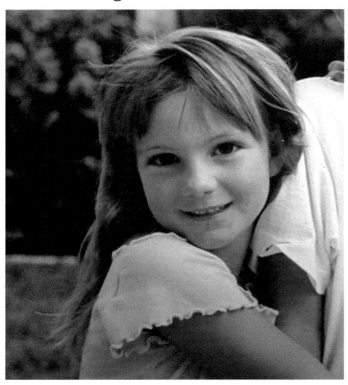

in an area dark enough to give contrast rather than over the pupils. I laid some very subtle, cool highlights on the teeth and added a 'super' highlight to the bear's eye. Light-yellow highlights and near-white 'super' highlights were scumbled into the hair without blending. Paint applied this thickly will rise through any glazes that are laid. The painting now had to be left to dry before any more work could be done on it. At this stage observe the counterchange effect that has been achieved of the figure against the background tones. This had been carefully controlled from the beginning of the study.

(*Below right*) At this stage I applied a layer of retouching varnish, to restore depth, and a fat (oily) wash of warm green which was brushed irregularly across the background and lower parts of the figure. This was then tonked. The opacity of this layer varied, depending on how much white had been added to the wash, and partially obscured the first layer giving an opalescence to the colour. I overlaid the shadow areas of the hair and flesh with warm glazes to enrich their texture. A gentle yellow glaze over the bear took away his 'chalkiness' and a cadmium red glaze over his jacket created the intensity of colour it required. Tints were placed selectively over the lightest tones on the hair, down the right side of the face, the top of the shoulder, the eyes and teeth to soften them. Thinner, more transparent tints were laid over the accents of the face, making the expression a little more gentle. Dark glazes over the bear's nose and eyes added richness to both.

(*Opposite page*) For this final phase I lightened the teeth, allowing their whiteness to define the bottom of the top lip while dark accents defined their shape along their bottom edge. Light pinks through to white were now applied to the

(*Below left*) The left of the face was now gently extended, along with the eye – another minor re-assessment. Further highlights were placed down the right of the face, on the bottom lip, along the bottom of the white of the right eye. Note carefully how I placed the points of light in the eyes

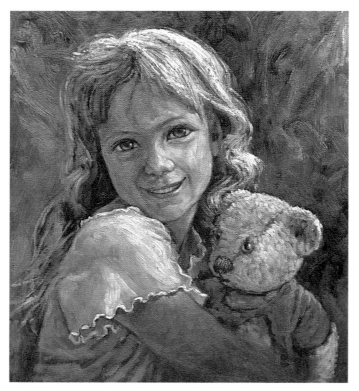

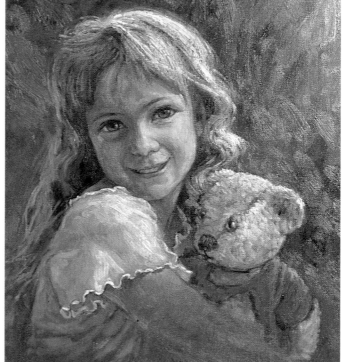

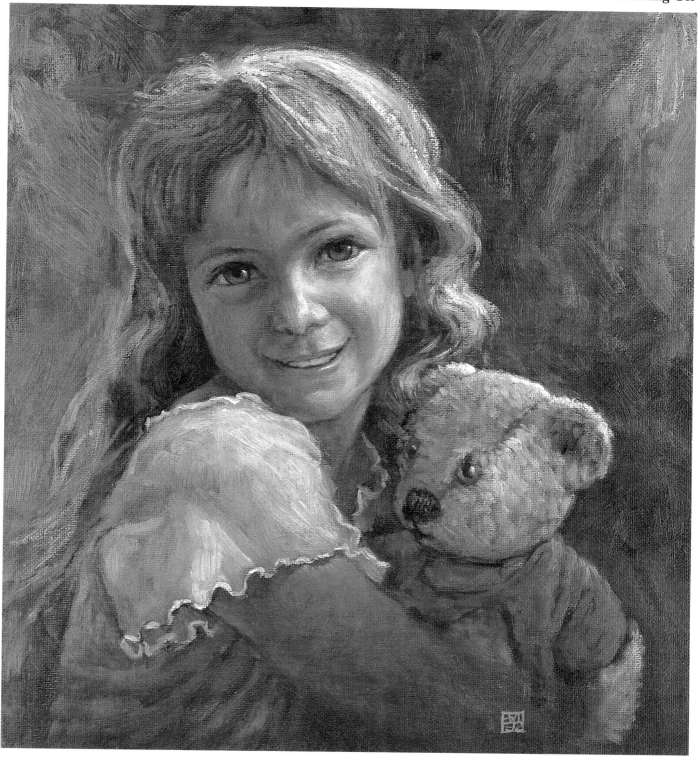

lips and bottom edge of the eyes, and some final white highlights placed on the skin. These are particularly noticeable on the nose and along the bottom of the right eye. Similarly, I scumbled some yellow highlights across the hair and bear's fur. Finally, I added a white 'super' highlight to the eye highlights already there. When I look at a finished piece, I always imagine how much will be lost under the frame. In this example it will give it a more compact feel which is just what I wanted.

Oil Painting: Out and About

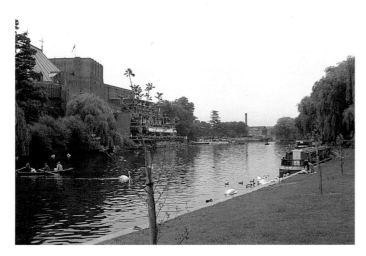

(*Below*) The painting, having been left for a week was now dry and looking at it with a fresh eye I felt that it was lacking in depth and softness. I decided, therefore, to introduce a series of tints which I hoped would remedy the situation. Firstly, these were laid across the far section of the river, right up to the far wall of the theatre on the left and up to and into the dark trees on the right. I worked a tint behind the bright trees on the left and the two boats on the river. This has the effect of lifting them forward from their grounds, achieving a greater sense of depth. I also laid a tint over the two red barges in the distance to make them recede even more against the red barge in the foreground. To further suggest the moist riverside atmosphere, the areas of sunlight on the theatre, banks and trees were given warm yellow tints. This diffused the light, giving it a glow as well as depth.

(*Opposite page, top*) I now introduced scumbled highlights over the background. It was important not to overwork these colours as detail is suggested much more effectively with loose brushmarks than by overworking. In a few areas the scumbles were softened into the tints beneath by blending, but where possible were left sharp, depending on the texture beneath to create irregularities. Note how, even now, the orange underpainting is still visible. The key to a good oil painting is in its layering, they should all remain visible or they will have served no purpose. Look at the grass on the right and note how the contrast between dark and light in the foreground reduces as the grass recedes into the distance.

(*Opposite page, below*) The foreground highlights were now introduced working from cool mid tones through light warm tones, to white. Any linework which was required was completed using a round nylon brush, with oil medium added to the paint to ensure fluidity. It is interesting on looking at the final piece how the tints, although still present, do not dominate. Instead our eyes are led around the picture by the highlight colours. It is very tempting for the beginner to paint these highlights first because it is these the eye picks out first. But you have seen that this study depends on the dark soft structures underlying the highlights to give it light and form. You must train your eye to look below the surface and to be patient in your build up, do not try and achieve the highlights too early on.

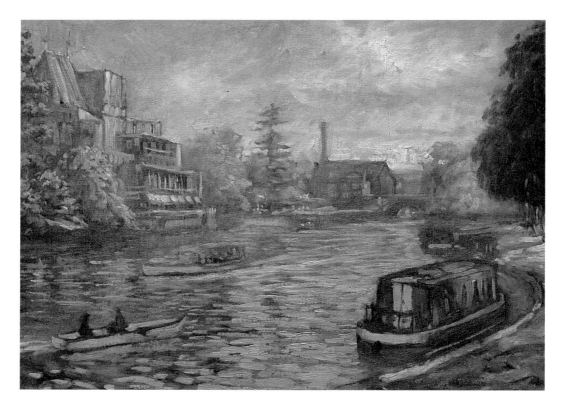

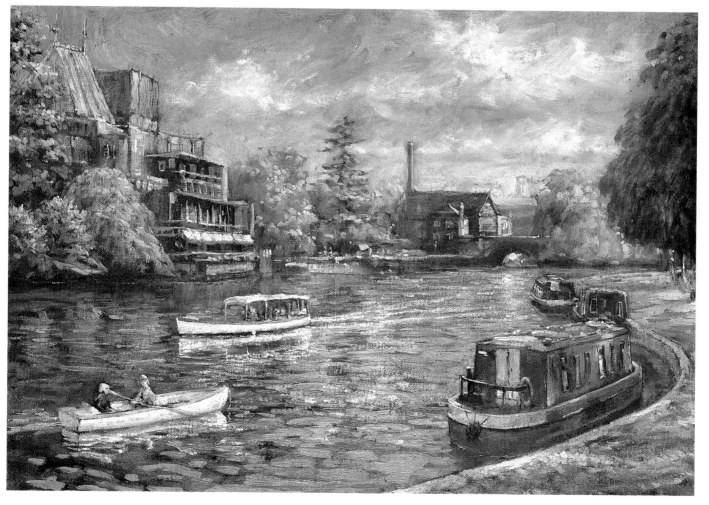

Oil Painting: Tricks of the Trade

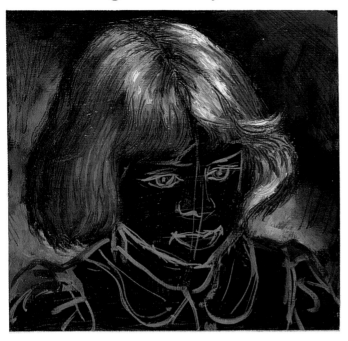

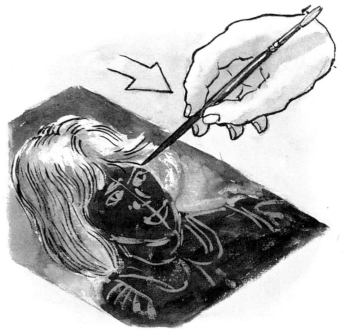

Sometimes blending paint, even with a bristle brush, produces too soft a quality. In this case, the heavy brushmarks can be broken up by means of sgraffito. Using this technique, the point of the brush shaft is scraped through the colour to create fine lines of texture. Sgraffito is particularly effective, as in this example, if your underpainting is dark because it will show through as dark accents.

Although oil painting is mainly about colour, you may wish, towards the end of your painting, to add some sharpness with linework. Although this can be achieved with small bristle brushes, it is easier to paint detailed linework using a brush that forms a point such as a soft hair or nylon brush. You can also add a small amount of glazing medium and possibly thinner, to the colour to make it more fluid. A rigger is an extremely fine brush designed to produce the linework for the rigging in paintings of sailing ships and is a most useful addition to your brush family. Any lines applied can also be lost in parts, while still wet, by blending into the background with a clean brush.

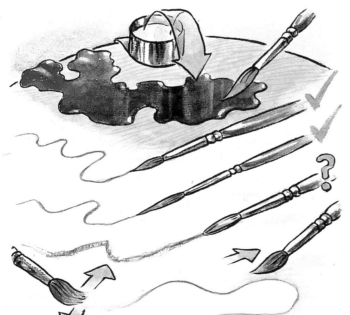

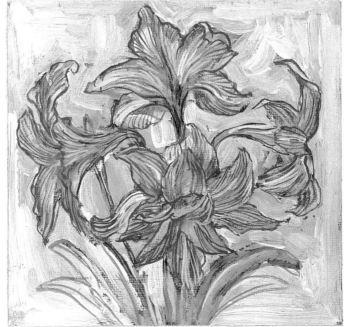

Here we see a typical palette mix, starting with a dark mix on the left which has been progressively lightened towards the right by adding white. Note that as the white was added, it was not mixed with all the colour, but a small quantity mixed at the edge of the darker tone. In this way you will be able to darken the colour again if it suddenly becomes too light or you later require a darker colour. It also prevents you from ending up with huge quantities of mixed colour in an attempt to make it light enough.

This shows a typically blended brushmark. Along the top edge the blending has smeared the paint heavily into the background whereas along the bottom the blending follows the line of the edge to give a gentler more subtle quality.

On the left are a series of much smaller brushmarks, some of which have been blended into the background with a clean brush. Make sure you only tickle the edges of the marks when blending, or you will pick up too much paint, and also keep cleaning the brush to avoid too heavy a paint transference.

This is an excellent layering exercise to get you used to the idea of painting wet on wet. You must use increasing amounts of colour on your brush as the layers build up. Giving each layer a separate colour enables you to see exactly where the paint is lying and will prevent you over-working or running out of colour because if you do so the colours will not stay separate but will mix together.

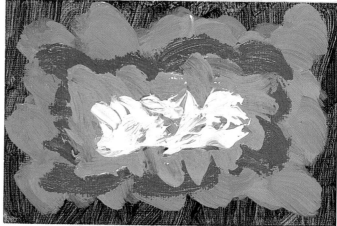

Oil Painting: Common Problems

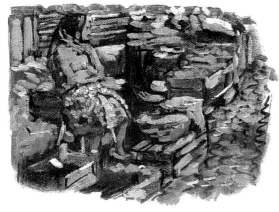

PROBLEM Painting looks crude. The brighter areas seem unrelated to the dark shadows and underpainting because they have been applied too quickly and too harshly, without enough tonal build up.

SOLUTION Build towards the light areas slowly, blending edges as you go. Don't place the lightest colour directly on the darkest. Place highlights on top of already lightened areas. The final white takes on the characteristic of the colour below, for example, white on top of light blue will look blue, but on top of orange will look orange.

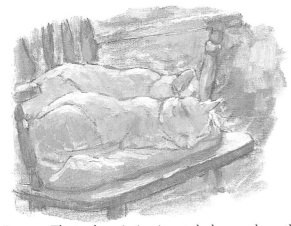

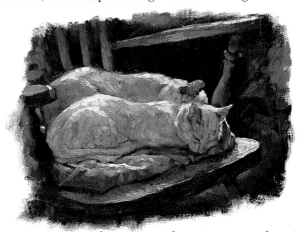

PROBLEM The underpainting is not dark enough, so there is no contrast for the lighter colours to shine against. You cannot suggest light if there are no dark areas. However, without dark tones the colours are forced to work more and you may like the lively impressionistic effect this gives.

SOLUTION Use complementary colours in your underpainting mix to give dark tones and use less turpentine. Keep the underpainting smooth by working and rubbing it in to the surface rather than by diluting it.

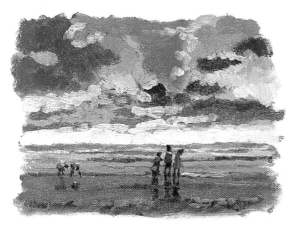

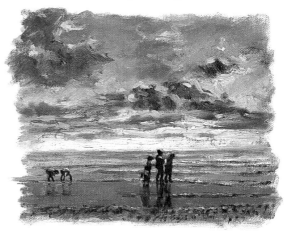

PROBLEM There is no excitement in the brushmarks. The colour is flat and dead and the texture too regular.

SOLUTION Firstly, don't overmix the colours, keep them slightly streaky. Secondly, don't overpaint but allow the underpainting to shine through, creating contrast. Thirdly, vary the direction, speed and pressure on your brush and the amount of paint it carries – this will create a variety of brushstrokes.

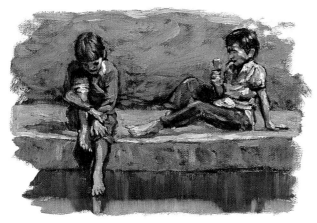

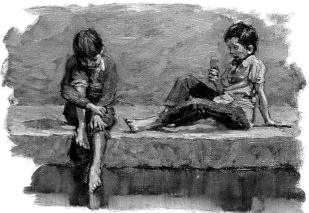

PROBLEM Creating light, bright colours in the middle and highlight layers is difficult. Adding white to make them light enough, also dulls them and turns the colours to pastel tones, i.e. red and white gives pink. A bright but light red is required. The background is also too dominant.

SOLUTION Create the tonal contrasts and then leave painting to dry. Then glaze with the colour you require. The transparent glazes will give you the richness you require. Apply a tint to the background to knock it back.

PROBLEM Here there are many colours, but not enough tonal variation. The result is dazzling and confusing to the eye. The blue outline was applied in an attempt to hold it together. You may of course like this unusual tonal balance which excites the colour.

SOLUTION Concentrate on the tonal balance of the composition. Try starting with a small number of colours, mixing complementaries to create your tones and adding white for highlight colours.

PROBLEM Here there are too many dark colours. The painting seems rather dismal and lacking in life especially when glazes darken it even more.

SOLUTION Concentrate on creating a range of tones. Building up the structure of your painting so that, if you do glaze, the picture will not lose its feeling of light.

Using Acrylics

Acrylic painting has been with us since the 50s, and despite its versatility, is vastly misunderstood by the majority of its would-be exponents. There is a common misconception that acrylics can replace both watercolour and oils. Although many of the techniques which can be applied to these media can also be applied to acrylic, it should not be thought of as superior or inferior to them. Those artists who have worked extensively in the more traditional media may at first find the behaviour of acrylics frustrating as its resemblance to watercolour or oils is purely superficial. Acrylic should be seen as a medium in its own right with its own strengths and weaknesses and you must set about discovering these if you are to exploit its potential to the full.

In acrylic paint the pigment is suspended in a watery, milky emulsion of acrylic resin or medium. When the water evaporates off, this resin forms a tough, transparent, plastic layer, holding the pigment permanently to the surface. The paint, while wet, can be thinned down, but once dry forms a flexible, insoluble film. This is excellent for wet-on-dry techniques as the paint dries quickly. Reworking, however, has to be done at speed and great care has to be taken that paint doesn't dry in your brushes.

The acrylic resin (glue) in emulsion (fluid) form, i.e. while the paint is wet, is milky in colour. On drying it becomes clear and this changes the overall quality of the paint. The tone becomes darker and the colour becomes more transparent. This means you have to gain considerable experience with the medium before you can handle this change effectively. It is probably better to use thin layers of colour to begin with so that this effect is kept to a minimum. Once it has dried, you can, of course, see the change, but you cannot then rewet it. The speed with which it dries, however, does mean you can paint over it very quickly.

Acrylic resin also has excellent adhesive properties so it can be combined with collage and montage for exciting mixed media work. These adhesive properties also allow it to be painted onto almost any ground, apart from those which are very shiny, such as glass or enamel. The latter, therefore, make excellent palettes as the acrylic will float off in an almost solid film when they are immersed in hot water. Acrylic does not have to be applied to primed grounds as the acrylic, when dry, is almost totally inert. This frees you to work on anything from watercolour paper to wood and to exploit the textures which they provide. The extreme flexibility of the dry medium opens up these possibilities even further as it means that you do not have to work on rigid surfaces.

Its all round strength and versatility means you can exploit many oil and watercolour techniques, applying it thickly or watered down to thin washes. It is probably best, however, used in flat, even areas of colour. One thinks in terms of an artist such as David Hockney, who has exploited to the full, the flat colour with its gently textured surface. Hard-edged techniques employing masking tape and/or paper stencils are very popular and suit its smooth paint surface. I often feel that the natural surface qualities of acrylic resemble gouache (opaque watercolour) more than they do true watercolour which is transparent, or oil which is more textured and richer in quality. Because of the speed of drying and nature of the paint, stippling is especially effective. Tones and colours can be built up in this way and mixed visually on the surface to give an embroidered-like quality of interweaving patterns.

There are a number of additives which can be combined with acrylic paint to make it even more versatile. The paint can be used to stain surfaces, especially unprimed ones, if it is mixed with a few drops of water tension breaker. This improves the flow of the colour and allows it to be absorbed into the fibres of the ground more readily. The soft effect this creates proves an excellent foil to the hard edges just described.

The fact it dries so quickly is sometimes a problem, but can be overcome by the addition of a retarder. While not giving you the long reworking times of oil it does at least slow the process down to a manageable level.

Because acrylic dries by evaporation, unlike oil which dries as the result of a chemical reaction, it loses much of its bulk. Textures, therefore, do lose some of their impact on drying although you will find that different brands hold their textures to varying degrees. You can, however, consider adding texture paste or texture medium to your colour, or building it up as a layer before you begin painting. Texture paste is composed of acrylic medium into which marble dust has been added and it dries like a flexible concrete onto the surface. It can be applied with finger, brush or palette knife and will provide you with all the varieties of texture you may require.

The fast drying time and permanence of acrylic makes it an excellent partner for many other media, for example, it provides a very stable base for oil painting. Washes of acrylic not only give a fast drying colour and texture on which the oil can be layered, but also prime the surface.

Pastels also benefit from such underpainting. Here, apart from the colour, the acrylic provides the tooth or texture to which the pastel can cling. With an underpainting of acrylic or texture paste, many more layers of pastel can be applied than to a flat, smooth surface. The brush-like quality of the marks will also lend an added dimension to the pastel surface.

Acrylics: Materials and Preparation

PAINTS Squeeze an inch of acrylic paint from its tube and the differences between it and the more traditional media immediately become apparent. The colours are bright, almost fluorescent and have a light, creamy consistency. This is as a result of the medium it contains which is white while wet. As it dries, however, it becomes transparent, changing the tone of the paint. It is almost as if you were looking at a tint of the hue (colour) which is going to become a pure hue (colour) as it dries.

Acrylic and oil paints do not mix, although acrylic does produce a very stable ground on which to paint your oils, once it has dried. You cannot, unfortunately, paint your acrylic on top of oil as the oil is too slippery for the acrylic to grip and it peels off.

It will mix with watercolour or any other water-based medium. You can in fact buy acrylizing mediums to give your watercolour or gouache the same water resistant, transparent, gloss finish that acrylics have when dry.

SURFACES Acrylics can be used on almost any surface, apart from an oil-based ground, glass or ceramics. Most of the ready-primed surfaces of paper, board and canvas are acrylic primed so that they accept both acrylic and oil paint. If you prefer to prime your own surface, I would recommend using acrylic gesso primer.

CARE OF BRUSHES Acrylic's fast-drying qualities mean you can layer heavy paint within a relatively short time. This is obviously a great advantage; it does mean, however, that you have to be especially careful with your brushes. Don't leave them lying around filled with paint, even for a moment, as before you know it they will be rock solid. You must wash them thoroughly with cold water and soap.

MEDIUMS There are various mediums that can be mixed with acrylic paint. Gloss or matt mediums are used for thinning down the colour while retaining its durability and finish. There are also gels for thickening the paint. This mixture can be applied with a bristle brush or palette knife to create texture. You can buy water tension breaker which increases the flow of the colour across the surface allowing it to be absorbed more easily and stain the ground. Retarding medium slows down the drying process and texture medium (paste) creates texture.

VARNISHES Finally, when your work is complete there are special varnishes for protecting the surface from air pollutants such as acid or tobacco smoke. These again can be bought with a gloss or matt finish or can be mixed depending on your taste. Never varnish with acrylic medium as opposed to acrylic varnish. It will soon look like plastic, will pick up dust and dirt and cannot be removed. The idea of all varnishes is that they can be dissolved away, carrying surface discolouration with them. Oil painting varnishes can be used over acrylics.

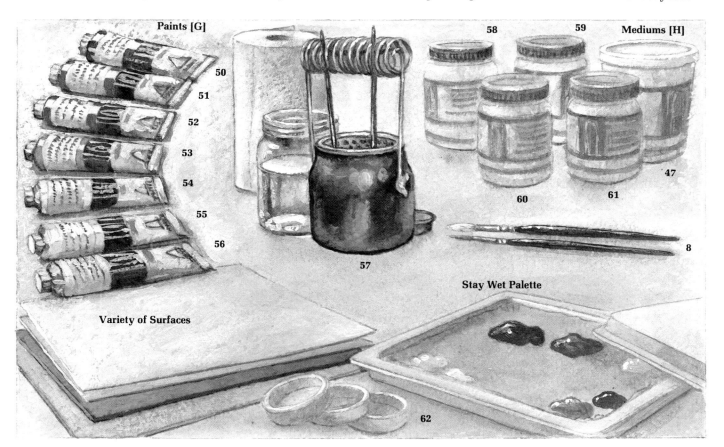

Paints [G]
50
51
52
53
54
55
56
57
Variety of Surfaces

58 59 Mediums [H]
47
60 61
8
Stay Wet Palette
62

(See list of materials on page 127 for key to numbers) 119

Acrylic Painting: General Tips

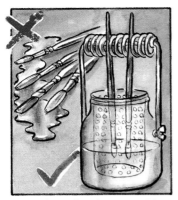

Never leave brushes out with even a tiny amount of paint in them. Keep them instead, suspended in a brush cleaner where they will not dry out during use.

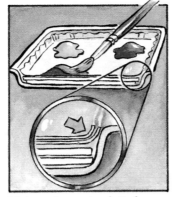

Make a stay-wet palette from a plastic butcher's tray. Above shows overlapping greaseproof paper which keeps 2 layers of wet blotting paper beneath clean.

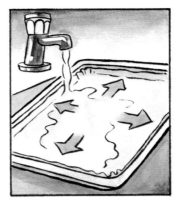

Give your stay-wet palette a good soaking. The greaseproof paper expands and wrinkles so pull it taut from the edges.

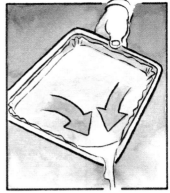

Pour off all excess water before you deposit any colour on the surface.

Place mediums as well as colours directly onto this damp surface. Use a second tray as lid. Such precautions prevent your paint drying out too quickly.

Replace caps on tubes, and lids and inner seals on pots as soon as you have finished with them.

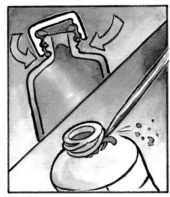

If tube caps become clogged with dry colour, scrape out with a strong pointed implement, or air may enter and dry out the paint. If colour is wet, wipe out with damp cloth.

Working on paper: it is a water-soluble medium and will cockle paper, so stretch this before starting.

On board: try breaking up the regular pattern of the canvas texture by applying a layer of texture (modelling) paste with brush, finger or knife.

On raw canvas: apply your first layer thinly with water plus water tension breaker (or liquid soap) so that it will soak into the surface, thus priming it.

Once primed, if textures are too heavy or canvas has raised fibres, remove with sandpaper or pumice stone. Support the canvas from behind.

Varnishing: lie work flat, apply with long even brush strokes using a hog bristle brush. Use two layers – allow to dry between. Acrylic or oil varnish acceptable.

Acrylics With Pastels

Thin dark washes of acrylic were laid onto stretched pastel paper with watercolour brushes. These dark dull versions of the finished colours employed complementary mixtures of acrylic. They provide richness and detail when seen as accents between subsequent layers of pastel or where the latter is removed with a putty rubber. The dark palm fronds, for example, were exposed at a later stage of the picture. Many of the colours seen were achieved with layers of pastel applied using a stub. Be careful if you decide to fix thin layers of pigment like this as they can be dissipated completely.

The example you see here is quite heavily overlaid with pastel. The sky for example has very little of the undercolour showing through. You could, however, produce a line-and-wash painting in acrylic which might be partially or very thinly covered with pastel.

On the other hand, the painting may be completed using a limited palette comprising of blue, brown and white. In this way you could work out the tones of the painting and add any colour variations in pastel. Certainly, I have found that using an acrylic underpainting in this way overcomes two of the major frustrations that many beginners feel when using pastels – that of creating dark colours with their pastels and not having enough variety of colour in their pastel range.

Here the acrylic adds another dimension to pastels, that of texture. Once the composition had been sketched out, a heavy layer of texture or modelling paste was applied using oil-painting bristle brushes. These textures followed the structure of the painting and once they were dry, were overpainted in dark, dull acrylic washes. Again, these were allowed to dry before the pastel work began.

Applying pastels to a heavily textured surface like this has many advantages. Firstly, the pastel has a structured surface to which it can adhere. Many more layers of pastel can be applied to such a surface without the need for fixing. The second advantage is that the texture breaks up the pastel mark in an exciting and unexpected way. You must adjust to the surface as you paint and be suggestive rather than detailed in your approach. Thirdly, the surface now catches light in the same manner one would expect in a heavy oil painting. I find using this technique really exhilarating, but it does wear down your pastels very quickly. In very heavily textured areas the pastels sometimes disintegrate so, be warned, your working area can become very messy.

You can still use your putty rubber or knife to remove the pastel layers, exposing the acrylic underneath, if you want dark accents or details.

Acrylics With Oils

(*Above*) Here the canvas board was first prepared by brushing on a layer of texture/modelling paste using an oil painter's bristle brush. It was applied in an arbitrary fashion to break up the monotony of the canvas texture. It was left for a few hours to dry thoroughly and then sanded gently to remove any excessive lumps. Sanding also prevents the brushes being shredded to pieces on the very rough surface of raw texture paste. The line drawing was, once again, followed by a thin layer of acrylic wash to refine and darken the composition. Halfway through this layering process some extra texture paste was added to the figures to give specific detailed textures to achieve definition, for example, around their faces and hands which are focal points of the study. Again, this was gently sanded when dry and the washes continued. When the acrylic dried, the whole painting was retouched with oil retouching varnish, although an acrylic varnish could have been used if preferred.

To begin with the oil layer was applied as very fluid colour, achieved by mixing with small amounts of thinner and medium. This was tonked repeatedly (*see page 108*), not only thinning the layer to allow overpainting, but also allowing the acrylic underpainting to show through. The paint application became progressively thicker and tonking less frequent as highlights were added. Note how the oil brushmarks are broken by the uneven texture of the acrylic giving them a more irregular and exciting feel.

Both examples on this page were painted onto canvas boards, which are quite suitable being, generally, acrylic primed. In the first (*above left*), the acrylic was applied over the initial line drawing in thin dark washes. These were built up to refine the drawing and increase the density of the pigment, but remained as flat areas of colour.

Soft, round, nylon brushes were used all the way through the painting. Large brushes laid the acrylic washes swiftly and loosely. Later detail required smaller sizes.

The acrylic layer dried very quickly and then the oil paint was applied, starting with the background first and working towards the foreground figure. At the same time the thickness of the paint was increased and its tones lightened. Take a look at the painting and notice how the acrylic is therefore more visible in the background and how the scumbled, lighter oil colours, bring out the texture of the canvas, acting as a contrast to the flat areas of acrylic.

Using acrylic underpainting in this way is very advantageous to the beginner. The fast drying of the first layer means it can be swiftly and easily overpainted with highlights. In any type of painting, these are the cherry on the cake. They are the things that our eyes pick out first, but must be painted last, as they depend on the darker colours beneath to give contrast and strength. One needs discipline to build them up gradually and experience to overpaint them onto a wet surface, successfully. A fast-drying medium like acrylic eliminates such frustrations.

Acrylics With Collage

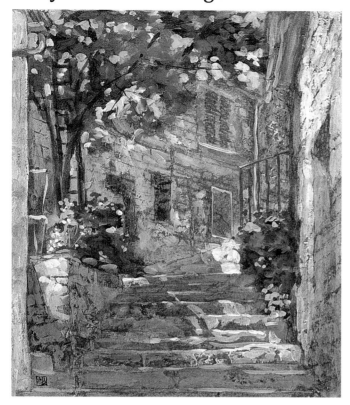

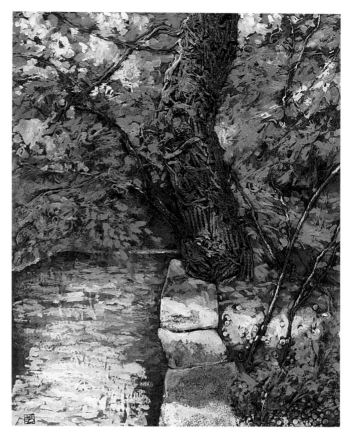

For this study I first stretched some watercolour paper on to which I glued five layers of sand-coloured pastel paper using acrylic matt medium. Once this was thoroughly dry, I sketched out the composition on the surface. I then attacked the surface with great gusto; cutting, tearing and scratching using the compositional sketch as my guideline. In some areas I went right down to the watercolour paper and in others, the surface was merely indented.

Once I was satisfied with this texture work, I applied some very thin layers of acrylic in warm and cool colours to define light and shadow areas. The thin colours soaked into the paper, particularly into areas where the fibres had been damaged. It took several layers of paint to achieve the density of tone which I required, allowing the surface to thoroughly dry between each one. The thin colour always dries much lighter than you imagine, due to the type of paper used rather than the paint itself. When satisfied, I gave the whole surface a layer of acrylic gloss medium to strengthen it and to enhance its depth of colour. Lighter colours were then scumbled on suggesting the play of light. The greens of the foliage and the red flowers were painted over uncut areas so that the soft, smooth brushmarks this created would act as a foil to the warm textures of the stone walls. All this final brushwork was kept light and fresh so as not to overdo an already heavily textured and worked surface.

Acrylic paint used on its own tends to have disappointing textures, but its strength makes it an excellent medium in which to embed textural items. The underpainting of this study, for example, was created with a mosaic of colours torn from magazine pages and fixed with acrylic matt medium. Having established the coloured masses of the composition, I then began to build up the textures using a variety of materials. The tree, for example, was made out of cut and unravelled pieces of string, dried daffodil petals created an uneven surface under the leaves, a scattering of lentils was used to break up the bottom right foreground area while torn card and sandpaper gave texture to the stone slabs. All of these items were generously smothered in matt medium, to fix and seal them onto the surface, and then left to dry.

You can fix almost anything to your painting surface, so use your imagination and look for a variety of forms and textures. Once these items have been fixed you can either retain or obliterate their identity by the application of colour. I first painted the string tree, for example, using dark colour and, once it was dry, lightened it with an uneven application of paint to suggest light falling across its surface. You could, of course, be very selective with your materials so that their actual colours represented the colours you required for each area of the picture. Seeds, for example, with their multifarious shapes, colours and textures could be used without the addition of any paint.

Understanding Colour Mixing

The primary colours, red, yellow and blue, cannot be created by mixing, but must be obtained straight from the tube.

They themselves mix together to achieve their secondary colours – red + yellow = orange, blue + yellow = green, red + blue = purple.

In theory, these colours make up the colour circle and are known as hues. Hues are all very intense (bright).

Sometimes, however, when two primaries are mixed, they produce a dull secondary, e.g. Prussian blue + cadmium red = grey.

In practice you need 2 colours for each primary: 1. RED Purple (Rp) 2. RED Orange (Ro) 3. YELLOW Orange (Yo) 4. YELLOW Green (Yg) 5. BLUE Green (Bg) 6. BLUE Purple (Bp)

Close primaries, then, mix to create bright secondaries 1. crimson red (Rp) + ultramarine (Bp) 2. cadmium red (Ro) + cadmium yellow (Yo) 3. lemon yellow (Yg) + Prussian blue (Bg)

But two distant primaries produce a dull mix. (Ro + Bg = dull grey). Therefore, each primary has a bias toward the secondary colour which it mixes brightest.

Try out the distant primary mixes yourself: cadmium red (Ro) + Prussian blue (Bg): crimson red (Rp) + lemon yellow (Yg): ultramarine (Bp) + cadmium yellow (Yo)

Complementary colours are opposite each other on the colour circle.

Placed next to or over one another their opposite nature creates a bright contrast.

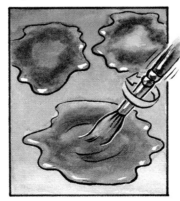

But mix them together and you achieve grey. Why?

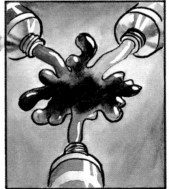

Because by mixing all the complementaries you are in fact mixing all the primaries together which would theoretically create black.

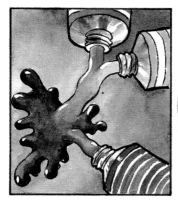

Mixing complementaries is equivalent to mixing all the primaries (above) and therefore black (or a very neutral grey) is created.

Colour can change in *hue*: red changing to purple or orange is a change of hue. All hues around the colour circle are intense (bright).

Colour can change in *tone* (sometimes called value or tonal value). This refers to how light or dark a colour is. (Above left: colour – above right: colour tones)

Colour can change in *intensity* which means its strength or brightness. (Above: decreasing intensity left to right). Also known as chroma.

Adding white in oils (*left*) or water in watercolours (*right*) creates a *tint*. This makes the colour dull as well as light as it decreases the colour's intensity and tone.

Adding black to either creates a *shade* and darkens the tone. But it also dulls the colour and often changes its hue. Try adding black to yellow and you will produce green.

Adding a darker colour changes the tone and the hue. Above, colour becomes darker, but also green. If we could eliminate the hue the change of tone alone would be seen.

Adding a complementary dulls and darkens the colour. Here the hue does not change but the intensity and tone does. This is one of the most important kinds of colour mix.

Adding a complementary and (a) white to oils (*left*) or (b) water to watercolours (*right*) changes the intensity only eventually creating greys.

To change a colour you can therefore move through the hues by moving around the colour circle or . . .

change its tone and intensity by adding its complementary or . . .

change its intensity alone by adding its complementary and (a) white to oils or (b) water to watercolours.

Colour Mixing in Practice

Specific colour mixing: how do you start to mix a specific colour, in this case this subtle tree green?

Firstly, find its hue, i.e. what colour is it – the tree featured is a blue green – the pure hue however is very intense and too dark.

Secondly, decide on its tone or value.

If your initial hue (*top left*) is too dark in tone you can add water (for watercolours) or white (for oils) to the mix.

Conversely, with a tone which is too light you can add more pigment (hue) to the mix.

If the pigment (hue) itself is not dark enough a complementary colour is required. This will darken your colour while not changing its hue.

Find the complementary by looking at the opposite side of the colour circle. You can see how a simple hand-drawn colour chart will furnish the answer (*below right above*).

Thirdly, decide on its intensity . . .

. . . and add its complementary until you achieve the correct intensity (chroma).

Eventually this balance between hue, tone and intensity brings you to the exact colour mix. Experiment with some difficult mixes.

Browns: although these are natural earth pigments, they can be mixed from the warm colours by adding their complementaries.

All the colours have warm and cool associations and the colour circle is therefore loosely divided into warm and cool colours.

Materials

The materials listed below were used by Paul Taggart to produce all the illustrations and paintings for this book. Any item followed by a number in brackets is illustrated on one of the following pages: 18–19 (watercolours), 52–53 (pastels), 86–87 (oils), 119 (acrylics).

Watercolours

PAPER [A]
Fabriano Artistico Rough (300gsm/140lb)
Fabriano Designo 50% Rag/ Hot Pressed (350gsm/ 160lb)
Fabriano Designo 50% Rag/ Rough (300gsm/140lb)

PAINTS [B]
Maimeri Artisti Extra Fine Watercolours (tubes)
Cadmium Red Deep (1)
Alizarin Carmine (2)
Prussian Blue (3)
Ultramarine (4)
Primary Yellow (5)
Cadmium Yellow Deep (6)
Phthalo Blue (7)

BRUSHES [C]
Osborne & Butler round sable, series 990, Nos. 6, 8, 10, 12 (8)
Osborne & Butler flat wash nylon, series 991
Osborne & Butler 44mm hake, series 993S (9)

MISCELLANEOUS
Osborne & Butler rectangular palette (10)
Maimeri latex masking fluid (11)
Maimeri Ox Gall
Maimeri watercolour medium
The Master's Brush Cleaner and Preserver (12)
Maimeri Kneadable putty rubber (13)
Clutch Pencil (2mm) 2B lead (14)
Automatic Pencil, 0.5mm (15)
Clutch pencil sharpener (16)
Scalpel or craft knife (17)
Gumstrip 5cm (2in) (18)
Small palette for Indian ink or masking fluid (19)

Pastels

PAPER
Fabriano Tiziano: various tints (160gsm/75lb)

PASTELS [F]
'Unison' Best Artists' Quality Soft Pastels
Red Crimson Nos. 8, 9, 10, 11, 12
Yellow Gold Nos. 8, 9, 10, 11, 12
Green Nos. 2, 8, 9, 10, 11, 12, 14
Green Earth Nos. 8, 10, 11
Blue Violet Nos. 6, 7, 9, 11, 12, 17, 18
Blue Green Nos. 1, 2, 3, 5, 9, 10, 11, 12, 18
Grey Nos. 7, 8, 9, 10, 15, 18
Basic Nos. 7, 8, 9
Red Earth Nos. 7, 8, 9, 10, 11, 12
Brown Earth Nos. 1, 2, 3, 4, 5, 6

MISCELLANEOUS
Maimeri fixatives: aerosol and liquid (40)
Coates willow charcoal
Osborne & Butler graphite stick and holder
Masking tape (41)
Mouth diffuser for liquid fixative (42)
Osborne & Butler waterproof Indian ink (43)
Osborne & Butler rigger (44)
Maimeri mahl stick (45)
Maimeri universal canvas carriers (46)
Maimeri modelling paste (47)
Pentel brush pen (48)
For blending: cotton buds, compressed paper stub and rolled paper stub (49)

Oils

CANVAS BOARDS
Osborne & Butler, 4mm thick (39)

PAINTS [D]
Maimeri Artisti Extra Fine Oils
Burnt Umber (20)
Ultramarine Deep (21)
Prussian Blue (22)
Cadmium Yellow Lemon (23)
Cadmium Yellow Medium (24)
Cadmium Red Deep (25)
Alizarin Carmine (26)
Titanium White (27)

BRUSHES [E]
Osborne & Butler hog hair round, long handle, series 981, Nos. 6 and 8 (28)

MISCELLANEOUS
Maimeri finishing varnish (29) and retouching varnish (30)
Maimeri glazing medium (31)
Maimeri palette knife (32) and painting knife (36)
Maimeri odourless (33) and oily thinner
Maimeri distilled turpentine (34)
Turpentine substitute or white spirit (35)
Maimeri dippers, nickelled brass with lid (37)
Maimeri rectangular and oval (38) wood palettes
Maimeri drying gel medium

Acrylics

PAINTS [G]
Maimeri Brera Artists' Acrylics
Cadmium Red Medium (50)
Deep Magenta (51)
Ultramarine (52)
Cerulean Blue (53)
Cadmium Yellow Light (54)
Cadmium Yellow Medium (55)
Titanium White (56)

MEDIUMS [H]
Maimeri matte medium (58)
Maimeri gloss medium (59)
Maimeri medium gel (60)
Maimeri retarding medium (61)

MISCELLANEOUS
Maimeri anodised aluminium brush washer (57)
Stacking ceramic palettes for small mixes (62)

General

EASEL
Maimeri portable wooden box easel (as used by Paul Taggart)

PAINTS
Maimeri Extra Fine Designer Gouache
Burnt Umber
Titanium White
Cadmium Red
Primary Red
Lemon Yellow
Deep Yellow
Primary Yellow
Ultramarine Deep
Prussian Blue

Art Workshop with Paul Taggart is the name Paul works under as a painting tutor, organizing courses around Great Britain, along with painting weekends and holidays.

In addition to the books he has written, a series of videos are now available featuring Paul and giving step-by-step instruction on how to paint along with invaluable tricks of the trade.

Art Workshop with Paul Taggart: Watercolour Painting
A comprehensive and inspirational guide to watercolour painting.

Art Workshop with Paul Taggart: Your Painting Companion
An intensive introduction to watercolours, pastels, oils and acrylics.

For further information about the videos and/or courses, please send an SAE to:
Miss E M Tunnell
PROMAD
15 Lynwood Grove
Sale
Cheshire M33 2AN

Acknowledgements

Once again, family and close friends have supported me throughout the time that it took to produce the work for this latest book. Their patience and understanding of my need to concentrate on this project is something I deeply appreciate, and to them I say a heartfelt thank-you. As indeed I do to all those who had a hand in directly helping this book along.

Janet and Ron, who unhesitatingly agreed to join me on the jacket of this book. John Strickson of Dunham Massey Hall, Altrincham, Cheshire; who 'washed' the hall and gardens in rain so that they were sparkling and clean, ready to be photographed for our jacket.

Dunham Massey Hall has provided me with a diverse range of subject matter over the years, some of which features in this book. As do paintings of various locations in Europe, some of which have been inspired by friends such as Bruno and Miranda Cabrelli and John and Joan Williams.

Children have featured considerably in my work over the years and a particularly inspirational five years were spent in the company of one of this country's leading young people's theatre companies – Oldham Theatre Workshop. David Johnson, its Director, allowed me unrestricted access to every aspect of the company, from auditions through to finished productions. Eileen and I spent many hours lost in this world. The rich variety of subject matter allowed me full rein to work in all media. Some of the pieces in this book take Oldham Theatre Workshop as their subject. For instance the oil painting on page 6 shows a young stage-hand relaxing between shifting scenery and props.

Children's portraiture is always challenging; whether commissioned or not. Here again, friends have afforded me the opportunity of including a subject dear to their hearts, a grand daughter, Amber by name, grandchild of Johnnie and Vee Hamp.

As with *Watercolour Painting, Your Painting Companion* would not exist were it not for Hilary Arnold's belief in me from the word go. For that I thank you Hilary.

Not forgetting Cindy Richards and Behram Kapadia; editor and designer respectively, who, once again, teamed up with me on this book. The pleasure of working on such an intensive project is enhanced considerably when those involved in it are enjoyable to work with as well as highly professional. Cindy and Behram are both, and I am delighted to be associated with them.

The most important acknowledgement must go to my partner in life, Eileen Tunnell. Not only have all her unique talents been brought to bear in helping me to conceive and construct these books, she has been an invaluable support during the stressful times, when things didn't always go as planned. Eileen, you understood all the days I was lost in concentration in my studio; without you this book would not exist.

And finally, my life has been made much easier by the support of Osborne & Butler, who have continued to offer a superb service and have supplied all the art materials required to produce every artstrip, illustration and painting in this book.